Art Textiles of the World
SCANDINAVIA

volume 2

TELOS

© Telos Art Publishing
Brighton Media Centre
15 Middle Street
Brighton
BN1 1AL
England
editorial@telos.net
www.arttextiles.com

Edited by Matthew Koumis
Proof Reader: Katherine James
Graphic Design by Katharina Riegler, Bozen, Italy
Reprographics by Typoplus, Frangart (BZ), Italy
Printed by Karo Druck, Frangart, Italy

First printed in Italy September 2005

ISBN 1 902015 05 3

A CIP catalogue record for this book is available from the British Library

Notes
Biographies have been edited to a consistent length and are **selections** only.
Dimensions are metric and are shown height x width x depth.

Support from the Arts Council, Norway is acknowledged by Bente Saetrang and Ingunn Skogholt.
Bente Saetrang wishes to acknowledge contributions of Anne Kjellberg, senior Curator at The National Museum, Oslo and Jorunn Haakestad, Director of The Museum of Applied Arts, Bergen.

Photo credits
Ole Akhoj, Alf Magne Andreassen, Marisa Arason, Per Asplund, Anders Berg, Anders Sune Berg, Jan Berg, Randi Eilertsen, Marianne Grondahl, Jeppe Gudmundsen-Holmgreen, Nina Hart, Halvard Haugerud, Gudmundur Ingolfsson, Johnny Korkman, Ilmari Kostiainen, Tord Lund, Hans Luthman, Alan Mackenzie-Robinson, Helene Mortensen, Myr Muratet, Michael Olsen, Simo Rista, Bent Ryberg, Hans Skoglund, Christian Staehr, Jussi Tiainen, Rauno Träskelin, Sakari Viika.

Editor's Acknowledgements
This book is dedicated to Poppy, Tamsin and Maia - *carpe diem!*
Many thanks to Alison McFarlane, Inger-Johanne Brautaset, Ane Henriksen, Piila Saksela, Ulla-Maija Vikman and many others for helpful advice.

Contents

The Elemental and the Refined

Forged from deep within craft traditions of Northern Europe, innovative textile art in Scandinavia is erupting into the 21st century with a breathtaking combination of the elemental and the refined. In this volume of profiles of ten outstanding contemporary artists living and working in Denmark, Finland, Iceland, Norway and Sweden, several themes recur: an intimate bond with nature; an acute yearning for light (understandable in a land where the sun does not rise at all in the dead of winter); use of traditional techniques such as weaving – whether embraced, transcended or deliberately flouted; a stylistic flair for linear geometry of great elegance; a comfortable and sophisticated handling of modern technologies, in contrast to the alienation or techno-phobia which many of us feel; and finally a dynamic involvement with the architectural setting, enabled by the many opportunities for public commissions which have until recently been abundant.

As with previous volumes in this series, this book offers a personal selection of artists, presented in a spirit of celebration. It makes no claim to being a definitive guide, for several reasons. An in-depth survey across Scandinavia is beyond the resources of probably every writer/publisher partnership ("Don't give us advice, give us money!" – the Marx brothers). Then, any official

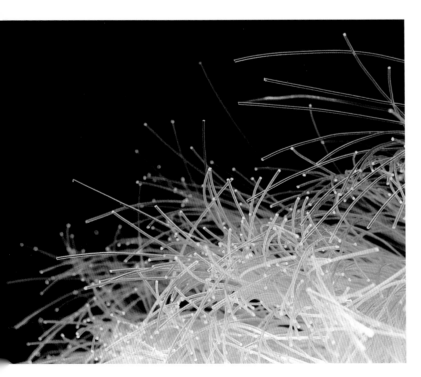

guide should by definition come from the Curator of the National Gallery of Contemporary Art or Applied Arts within each country; if after many years this is not forthcoming, it would be churlish to complain that Telos wishes to light a single candle rather than curse the darkness. Lastly, history tells us that contemporary art, be it visual, literary or musical, is very difficult to assess until one or two generations have elapsed. Beethoven, Van Gogh and James Joyce were all written off as harmless eccentrics by many of their contemporaries, but history has cast a richer judgement.

Those wishing for organised categories may prefer to return in 20 years' time; meanwhile Telos will continue to have faith in the eloquence of outstanding artists, and in their natural ability to inspire and surprise those of an open heart and mind.

Recently, Telos commissioned a survey, conducted outside the Tate Modern in London, to find out what the modern-art-going public think of textile art. Visitors were shown a variety of photographs of work from the 'Art Textiles of the World' series, and asked simply whether they thought the textile art was better than, equal to or worse than the art on display inside the Tate Modern. The public opinion was as follows (*):

72% textile art of equal status

10% textile art of greater status

8.5% textile art of lesser status

9.5% don't know

(*) Over 100 people were interviewed in 2005 by Caroline Puttock in preparation for *Sex, Drugs and Textile Art* (a Guide to the Appropriate and Inappropriate Presentation of Textile Art) by M. Koumis, publ Telos Art Publishing winter 2005. ISBN 1 902015 30 4

Agneta Hobin
2004
mica interwoven with steel
40 x 66 x 26cm

page 5:
Grethe Wittrock
Aqua (detail)
2004
nordic rya technique, transparent
blue nylon fishing line
130 x 140cm

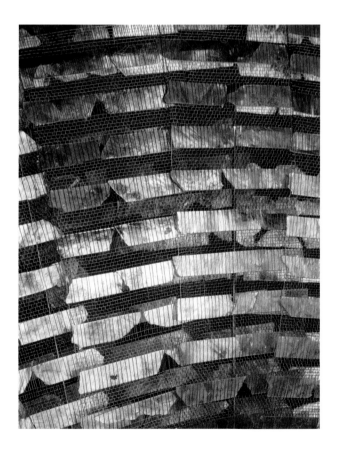

So more than four out of every five people interviewed consider the best of textile art to be equal to or better than mainstream contemporary art. What a pity that textiles are rarely on view in any Museum of Contemporary Art. Instead it is hung (if at all) in the Craft Museums, in between the sixties pots and the eighties earrings. You the reader are invited to form your own opinion of which is the more appropriate venue for work such as that shown in this book. This discrimination of venue and of status has many reasons – primarily sexism. The resulting injustice, which is a form of apartheid, could be described as artism.

This 'Art Textiles of the World' series emerged partly out of a desire to equip artists and gallery shops with a visual tool with which to gently confront this artism. (For a generation, textile art was sadly misrepresented by black and white 'how-to-do-it' books.) Telos books have a simple missionary objective: allow textile art to be considered of equal status with mainstream art.

What steps need to be taken to revolutionise the perception of textile art for curators, collectors, opinion formers and the public? Outstanding work needs to be exhibited regularly in major cities around the world. It is time for the Lausanne Biennale (the forum for international contemporary textile art which was disbanded in the early 1990s) to be replaced by something new.
Who will join forces in breaking out of the ghetto, acting as catalysts to make the necessary political and practical arrangements for work to be exhibited and so gain the artistic recognition it so richly deserves?

Matthew Koumis
Series Editor, Founder
Telos Art Publishing

Artists

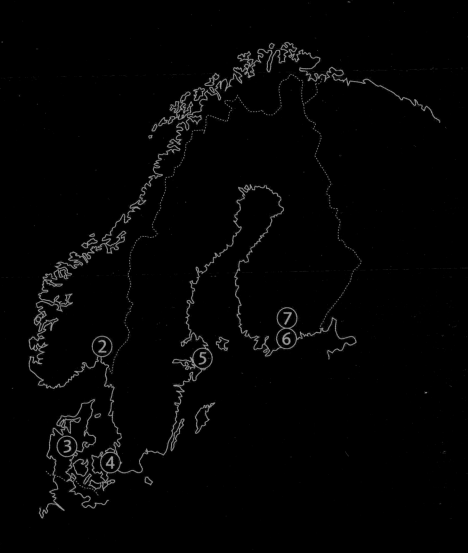

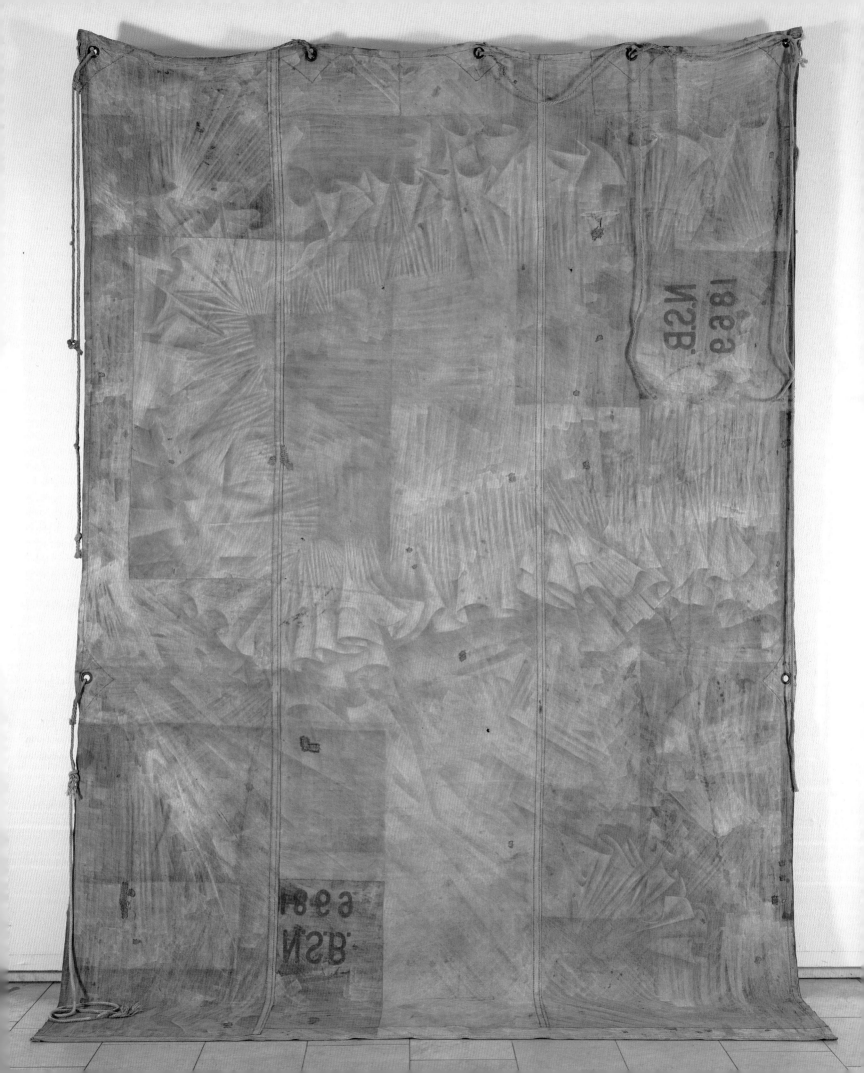

Bente Saetrang

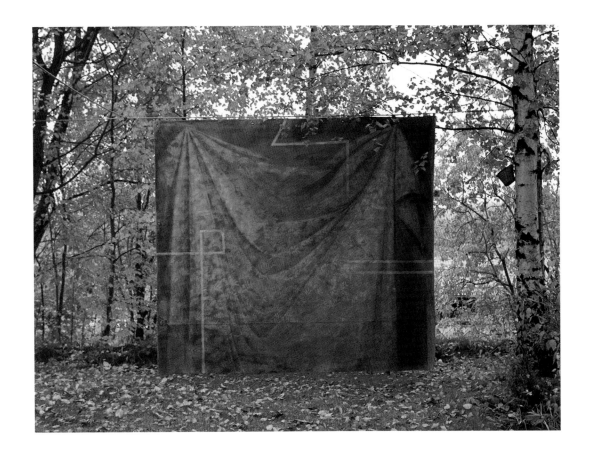

The textile material has its own language, historically powerful and symbol-
laden, charged, rich – while in everyday life being banal and necessary.
I wish to exploit and explore the depth of the textile language.

left:
Meeting point.html
1999
drawing on canvas
345 x 240cm

above:
In the Beginning
1995
stencils, spray,
pencil on canvas
260 x 230cm

In my works I seek to express personal experience and political commentary. I try to understand myself from a political perspective and want my art to reflect this awareness.

Technically, I work slowly and meticulously, trying to imbue my works with emotion and visual energy. Using traditional techniques, I print, sketch and paint directly on the fabric. The treatment of the surface may include additional elaboration, such as the sewing on of details – small things belonging to the textile world of care and durability – to highlight the textile origin and the distinctive quality of the material.

In Memory of Briham Boarram embodies a protest against violence and racism. Its title was the headline of an article in the French paper *Libération*: Bouarram was a young Moroccan who, on 1 May 1995, was attacked by three right-wing skinheads and thrown into the river Seine, where he drowned.

Every year, on the day of his death, young people gather on the riverbank around a piece of white fabric and throw flowers in the water. When I used to live in Paris I went down there once, and the sight of the white sheet lying by the river made a deep impression on me. The sheet appears in my work as white spots or wounds. These spots form a disturbing contrast to the colour red, which evokes associations both of pain and of the red May Day.

Visually the main motive is a patterned textile, hung like the wall draperies seen in medieval and Renaissance paintings. The pattern is also reminiscent of fabric fashion from the late 14th to early 15th centuries. Jeanne d'Arc may easily be pictured against such a background.

For some years I have focused on textiles as a motive and thereby approached the problem of representation. When a worn canvas cover forms the background of a pictorial rendering of, for example, a tablecloth, it may be difficult to distinguish sharply between the two elements. I work with ambiguity to challenge the viewer and invite reflection.

Once upon a Time
2003
layers of paint on canvas
315 x 320cm

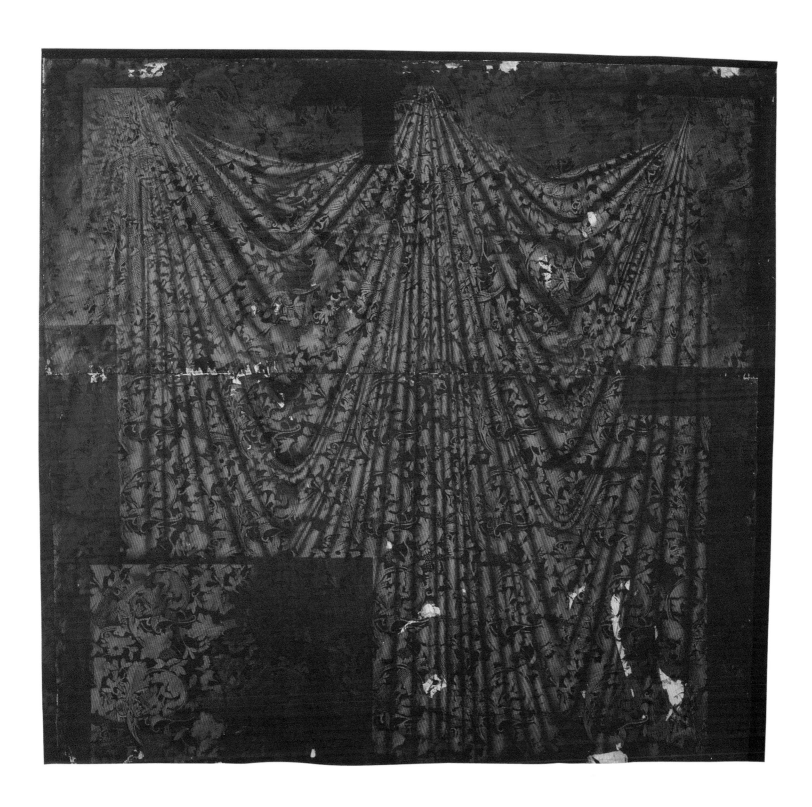

In Memory of Briham Boarram
1997
paint, pencil, silkscreen printing
on canvas
245 x 263cm

13 at the Table in Baghdad was finished only weeks before
the invasion of Iraq. The tense situation in the Middle East made
its impression on us all, and I felt that my drawing of a simple
tablecloth captured feelings of the ominous and the uncertain,
as well as bearing associations to the Last Supper.

Another work in the drapery-series is called *Meeting point.html*
(1999). I found an old and torn canvas cover, which had been
used on the railways. It was woven of lovely, long-fibred linen
which, when years of dirt had been washed out, became shiny
and beautiful. It had been carefully mended over the years,
and in itself exuded a very special aura. I exploited the traces
of wear and tear by drawing upon the canvas a picture of a
different fabric folding in and out of the surface. As a contrast
to the beautiful masculine canvas, I drew in a soft, translucent
and feminine piece of fabric – an old pillowcase, perhaps, or
some underwear or a nightgown. A meeting between two worlds.

I was interested in medieval *gobelins* when I started using
draperies as a motive. The use of well-worn canvas covers
emphasizes the traces of time past. The title *Once upon a Time*
suggests a time which could well be that of the medieval
gobelins, and the work can be seen as carrying the drapery
motive one stage further: I wanted to create a textile which,
rather than representing something else, was the drapery itself.

Translated by: Toril Hanssen

limited@unlimited.com
1999
drawing and silkscreen
printing on canvas
370 x 370cm

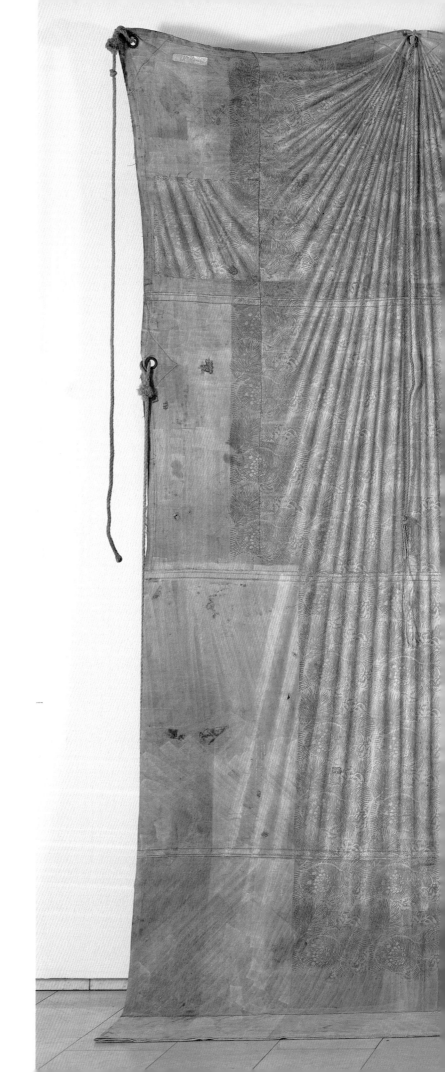

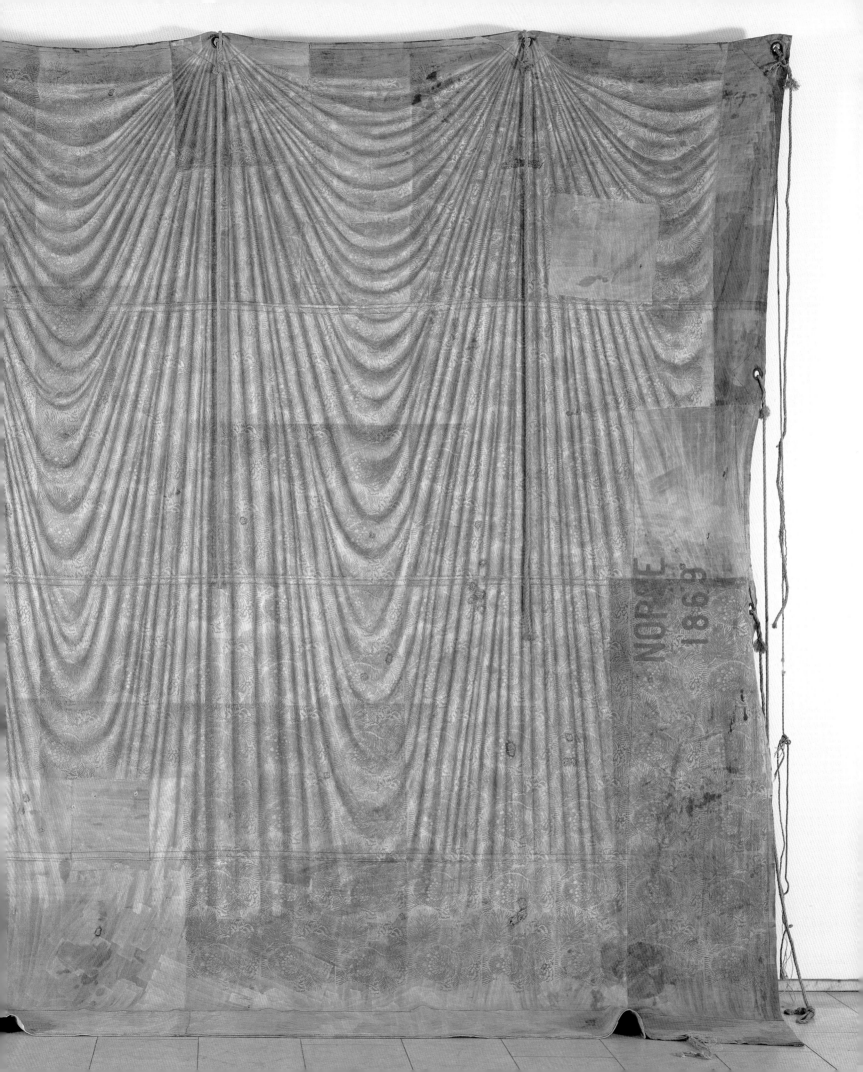

The Blacksmith's (Re)Collection
2000
drawing on canvas
120 x 150cm

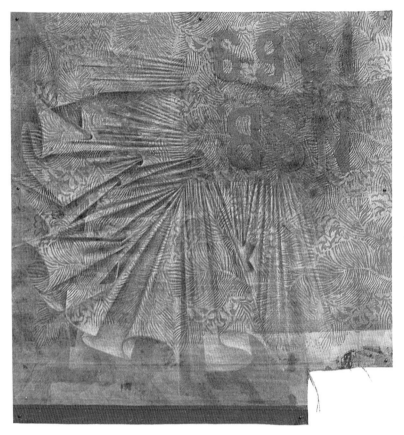

The Artist's (Re)Collection
2000
drawing, silkscreen printing
on canvas and iron
65 x 130cm

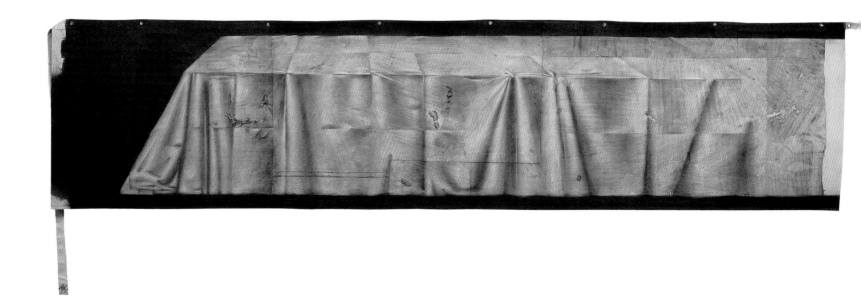

The wrinkles and wear apparent in the surface bear witness to life lived, artistically, in terms of the canvas cover and in terms of real life. Through these elements the life and history of the canvas and the work of art merge.

13 at the Table in Baghdad
2003
drawing on canvas
100 x 500cm

Born 1946, Oslo, Norway
Atelier Oslo, Norway

Education and Awards

1966-68	Philosophy and Art History, University of Oslo
1969-73	National College of Arts and Crafts, Textile Department, Oslo
1974	Academy of Fine Arts, Poznan, Poland (Magdalena Abakanowicz)
1990	Oslo City Artist Award
1993-	Guaranteed Income for Professional Artists
2000, 2005	Ingrid Lindbaek Langgaard Fondation/Cité International des Arts, Paris

Exhibitions

2005	Nor-Th, Bangkok, Thailand
2004	Museum of Applied Arts (solo), Oslo
	11th International Textile Triennale, Lodz, Poland
2003	Museum of Applied Arts (solo), Bergen, Norway (catalogue)
2000	Gallery Bomuldfabriken (solo)
1999, 1994	Artists' Association, Kunstnerforbundet (solo), Oslo
1995-97	7th Nordic Textile Triennale: Helsinki, Stockholm, Copenhagen, Oslo, Reykjavik, Riga, Tallinn, Vilnius
1994, 1995	Kulturhuset (Maison de la Culture) USF (solo), Bergen
	Nordland Music Festival (solo), Atelier 88, Bodø

Collections

2003	Museum of Applied Arts in Bergen
2003	Museum of Appied Arts in Trondheim
2003	Museum of Applied Arts, Oslo
1994	National Museum of Contemporary Arts, Oslo
1978	Norwegian Arts Council
1978-	Several private and public collections

Commissions

The National Bank of Norway
Lillehammer Hospital
The Norwegian Cancer Hospital, Oslo

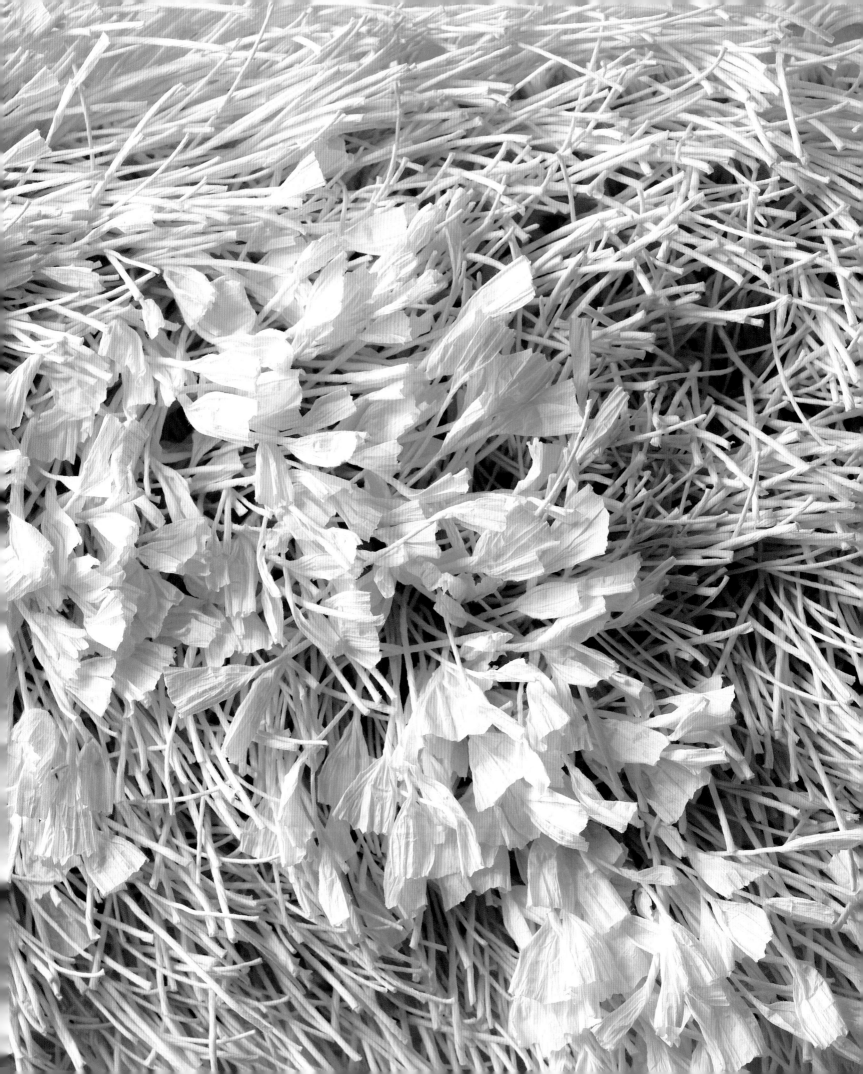

Grethe Wittrock

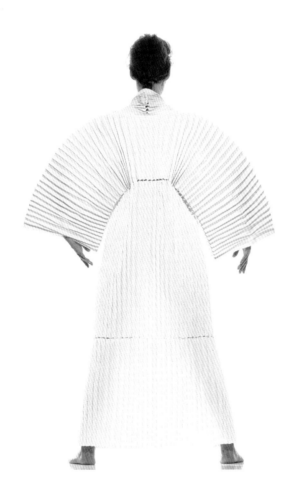

Time is in short supply in the world; it is rapidly becoming one of our most precious commodities. I feel rich as a textile artist; my vision of the future is that our time-consuming and precious medium of art textiles will become increasingly valuable.

left:
Lime Grass & Nordic Wind
2004
Nordic *rya* technique, paper yarn
60 x 20 x 7cm

above:
Kimono
1993
handwoven and handsewn
Japanese paper yarn

My studio is in the heart of Copenhagen, next to the Lake –
it is very light and has a lovely atmosphere. Here I have my
large Öxabäck loom and a long printing table, shelves laden
with all kinds of yarns, and my big silk screens. Also a variety
of personal treasures from my travels abroad which serve as
inspirations for my textile explorations: a window ledge filled
with stones collected on the Danish coast; a huge wall filled
with textile samples, ethnographic items, and so forth.

I was born in the countryside along the fjord, and from my
childhood I remember my fascination with the structure and
shapes of nature; that's really where my heart is. I am espe-
cially fond of all shades of blue and white, the colours of the
sea and the sky, the ice cold wind and the haze. The seagulls
are screaming outside my window. Structure, texture and
surfaces are essential in my works.

The raw material speaks to me and I try to respect its own
energy by creating works pared down to their essence. I try
to keep it simple and strong, yet poetic. I wish to achieve the
sublime by combining as few elements as it requires to create
that rawness and purity and perfection which I see in natural
elements, whether it be a smooth round blue stone, the shiny
inside of an oyster shell, or the fresh green moss.

The Traveller
2004
wall decoration
silkscreen print,
gold on paper, nylon fabric
3 pieces, each 3.15 x 2.22m

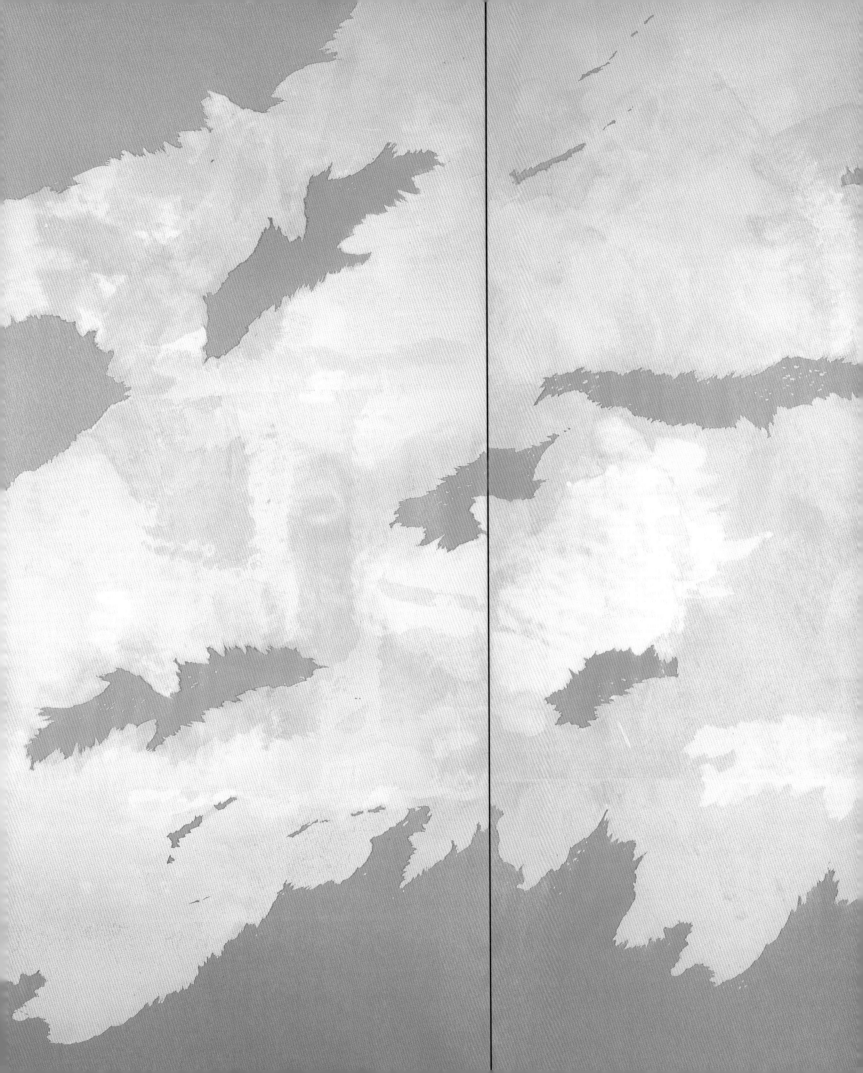

During a study year in Kyoto in 1991, I became fascinated with the Japanese paper tradition and made contact with a local paper maker. On completion of my stay I brought paper yarns and paper sheets back to Denmark with the purpose of experimenting with various techniques of weaving and structuring these materials. Together with fashion designer Ann Schmidt-Christensen I established Project Papermoon which questioned and challenged what textiles and clothing are and can be. It was an experiment with 100% vegetable Japanese paper yarns and paper sheets modified into textiles and formed as functional, sculptural clothing, combined into an integral unity of forms and materials. The collection, including *Kimono*, has been exhibited in galleries and museums throughout the world.

In 2001 I received a three year grant from the Danish Arts Foundation which made it possible for me to work on larger-scale works. In my wall hangings I was able to express a personal imagery.

Heart Blood takes the metaphor of blood in all its phases from free-running scarlet to the rust-red and clotted, the paper unfolded to resemble drops of blood, as a deeply felt comment on our unstable planet, where people every day sacrifice their lives in a war between financial and religious interests. *Peace* is a complementary work to *Heart Blood,* in which I express my hope for a peaceful world. Some of the paper yarns have been unfolded at the very end to add a feminine and poetic presence. They are both knotted in the Nordic *rya* technique onto a steel plate.

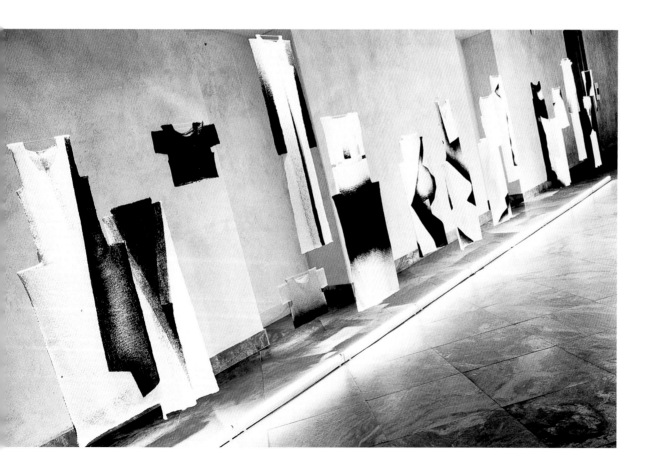

left:
Urban Camouflage
Paperclothes Collection
('Project Papermoon' series)
1997
woven and knitted airbrushed
Japanese paper yarn

right, above:
The Horse,
Jeune Couture Collection
('Project Papermoon' series)
1999
handwoven geometrically cut
silkscreen print, Japanese glass
paper yarn

right, below:
Project Papermoon
1995-97
unique paper clothes from
various collections made with
woven and knitted paper yarn,
paper sheet

Recently I have been doing commission works for Danish companies, including making sound-absorbent textile solutions; in the modern architecture of steel and glass, the qualities of textiles make a positive difference.

The Traveller is a wall decoration in three pieces, silkscreen printed with white-gold pigment on woven, pale grey, dyed papernylon fabric. The work takes its inspiration in part from my own curious travel experiences in the East, symbolised here in an image of a new and undiscovered land; and in part from the visionary outlook on architectural development of the commissioners (the Realdania Foundation, Copenhagen).

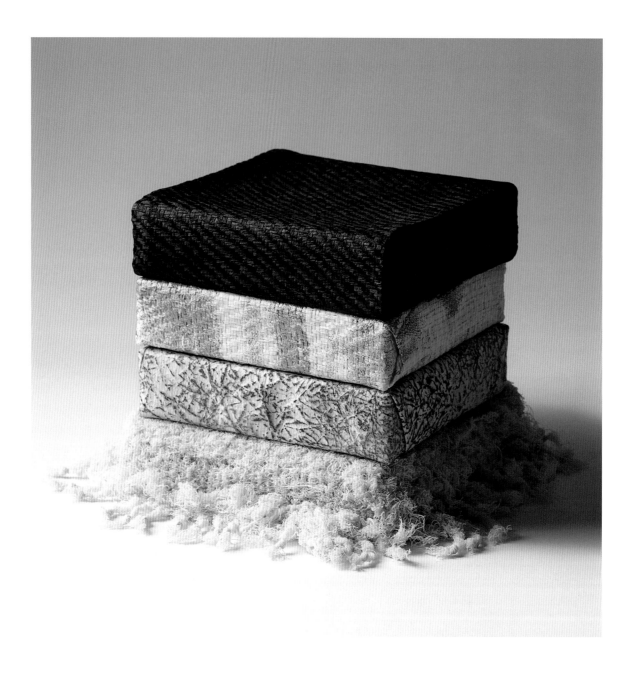

In the creative process I exploit the limits of the material. In the interplay between me and the material, the unexpected can happen and give that twist which makes it innovative and rewards it with a soul of its own.

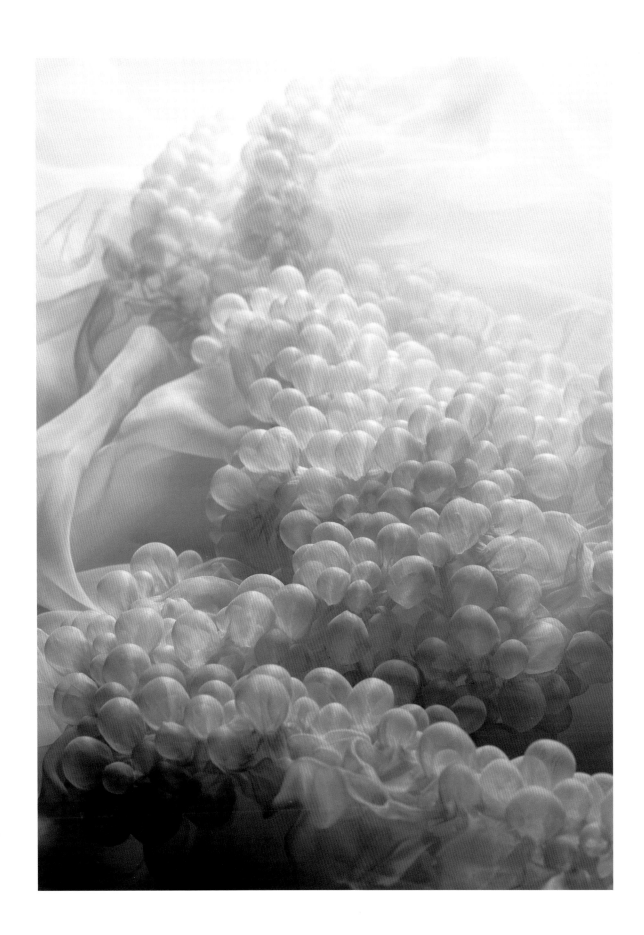

right:
Bobbles
2003
heat-treated shibori,
polyester organza
400 x 115cm

left:
Nordic Heritage
2002
handwoven, printed, dyed,
Japanese glass paper yarn,
kurotani paper sheet, wool
20 x 20 x 20cm

Heart Blood
2003
Nordic *rya* technique,
paper yarn dyed and laquered
120 x 140cm

Born	1964, Kalundborg, Denmark
Atelier	Copenhagen, Denmark

Education and Awards

1987-92	The Danish Design School, Copenhagen
1990-91	Kyoto Seika University, College of Fine Art, Japan
1992	The Arts and Crafts Prize of 1879, Silver Medal
1995	The Danish Design Prize, The Biennale Prize
1996	The Bavarian State Gold Medal, The Talente Prize
2001-03	3-year grant from the Danish Arts Foundation

Exhibitions

2004	'Nordic Cool, Hot Women Designers', Washington, USA
	STUFF, SuperDanish-Newfangled Danish Culture, Toronto, Canada
	SOFA Chicago 2003/2004 USA
	'Textile Art', Reykjavik Art Museum, Kjarvalsstadir, Iceland
2003	'Artists at Work', New Technology in Textile and Fibre Art, Museo del Tessuto, Italy
2002	'Small Work in Fiber', Jack Lenor Larsen, Long House Reserve, New York
	Issey Miyake Design Studio, Tokyo
2000	'Project Papermoon', Textilforum, Herning, Denmark
1999	'Jeune Couture', Invited by the Royal Danish Embassy, Paris
	Gallery Maronie, Kyoto, URBAN
1997	Charlottenborgs Efterårsudstilling, Copenhagen
	URBAN, Biennale-prize exhibition, Museum of Decorative Art, Copenhagen
	Challenge of New Materials Gallery, Science Museum, London
1996	'Paper-Art-Fashion', Badisches Kunstmuseum, Museum für Kunst und Gewerbe
1995	Biennalen 1995, Museum of Decorative Arts, Copenhagen

Commissions

2004	Fonden Realdania, Copenhagen
	Bank Pension, Copenhagen
2005	H. Lundbeck A/S, Denmark

Collections

Museum of Decorative Arts, Copenhagen

Nina Hart

In big blow-ups where recognizable textures and designs appear strange and immaterial, detached from their entirety and context, new stories are told.

left:
Blue Dress Culloden I
('Tartrans' series)
2001
Lambdaphoto
150 x 110cm

above:
Buchanan I
('Tartrans' series)
2001
Lambdaphoto
130 x 100cm

I am not really a genuine and faithful textile artist. Not only did I venture late into the world of textiles and textile art (having spent half my adult life working as a trained nurse) – I also ventured into that very new world by coincidence.

Having done a lot of photography in my spare time, I decided to quit nursing and become a professional photographer in 1979. My first step was a four-month stay at a High School, where, in addition to my photography, I attended textile-printing classes, purely out of curiosity. This curiosity sealed my fate and in 1980 I entered The Danish Design School's textile department, as one of the oldest students, graduating in 1986.

With hindsight now I can look back and recognize a certain pattern: that my consistent restlessness will betray me at approximately 5-year intervals and take me into strange moods, where an urge and a need to try something yet untried and completely new will conquer my training as a textile printer. I simply get a kick out of entering foreign land and, little by little, I have reached a point where I have to face the fact that I am addicted to that way of working.

The excitement of not knowing what will happen round the next corner keeps me going – along with the fear, the stress, the insecurity and the doubts – an inspiring cocktail! My inspirations are as variable as my work – and as undependable. Anything, really, can get me started, but once in the working process, I find that wide-open eyes and mind are of utmost importance, until that inevitable moment when the momentum of the work in progress takes over.

In 1992, after a visit to Japan, I became infatuated with paper and paper pulp, and for some years I worked with a combination of transparent textile and paper pulp in big reliefs. Having become familiar with the potential of paper, I moved on to three-dimensional works, and works using paper pulp on canvas, where I literally painted with the pulp in combination with other materials like iron dust, lead, raw colour-pigments, bees-wax and earth.

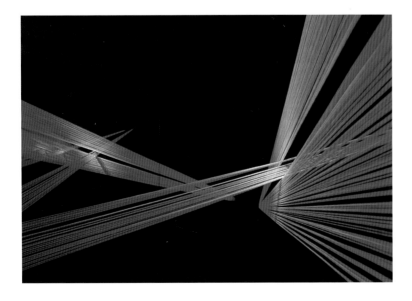

Reflections
1996
installation
white knitting yarn,
ultra-violet light, mirrors
400 x 400 x 150cm

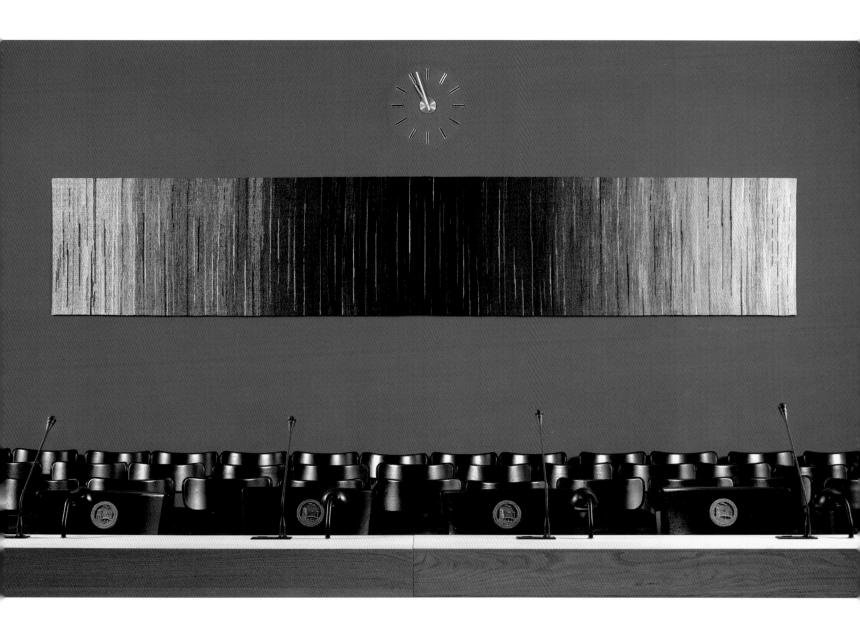

Rhythm in Blue
2002
wall decoration
woven flax, silk,
phosphorescent thread
Koege Townhall, Denmark
80 x 485cm

That era duly came to an end. In 2000 I found myself putting far too much energy into obliterating the paper pulp's inherent texture, in search of a smooth and cool surface, and I had to realize that time was up.

For the past four or five years I have turned the vessel upside down, so to speak. Instead of creating new textile works I start with already existing textiles: selected fabrics are photographically transformed, offering cool volumes of colour and space.

In big blow-ups where recognizable textures and designs appear strange and immaterial, detached from their entirety and context, new stories are told. The circle is completed. I have returned to my starting point.

Instead of creating new textile works I start with already existing textiles.

left:
Barflower 6
2002
Lambdaphoto
150 x 110cm

Black Carpet
1994
dyed paper pulp and wax
on steel mesh
300 x 250 x 30cm

above:
Side by Side
('Paper on Canvas II' series)
1998
dyed paper pulp, raw colour
pigments and beeswax on canvas
138 x 120cm

right:
Under Black Cover
('And Still Another War' series)
1999
dyed paper pulp, gauze,
putty, lacquer on canvas
105 x 120cm

The excitement of not knowing what will happen round the next corner keeps me going – along with the fear, the stress, the insecurity and the doubts – an inspiring cocktail!

Perforated Membrane
('And Still Another War' series)
1999
paper pulp on canvas
105 x 120cm

Born	1948, Copenhagen, Denmark
Atelier	Copenhagen

Education and Awards

1980-82, 1984-86	Danish Design School, Copenhagen, Textile Department (printing)
1982-84	Danish Design School, Copenhagen, Fashion Department
1992	Award from Ole Haslund's Artists Foundation
	Award from The Non-Nobis Foundation, Royal Academy of Fine Art
1994, 1996	Award from The Danish National Art Foundation
1995-97	3-year grant, The Danish National Art Foundation
2002	The Nordic Award in Textiles, The Fokus Boraas Foundation, Sweden
	Member of the Danish Artists Society

Exhibitions

2002	'The Nordic Award in Textiles 2002' (solo), Focus Foundation, Borås, Sweden
1999	'And Still Another War' (solo), Æglageret, Holbæk, Denmark
1998	'Paper on Canvas II' (solo), Gallery Pagter, Kolding, Denmark
1995	'Paper on Canvas I' (solo), Traneudstilling, Gentofte, Denmark
	'Nina Hart' (solo), Kabinettet, DAC, Copenhagen, Denmark

Commissions

2005-06	Antependium and carpet for The Cathedral of Maribo, Denmark
2004	Redecoration and light sculpture for Hammel Townhall, Jutland, Denmark in cooperation with interior architect Susanne Christophersen
2002	Wall decoration for Koege Townhall, Denmark
2001	Postcards for the Museum of Ny Carlsberg Glyptotek
2000	Scarves for the Museum of Ny Carlsberg Glyptotek
1993-2000	Scarves and ties for Georg Jensen, Royal Copenhagen
1987-93	Textile designs for various fashion companies
1987	Wall decorations for the Scala-Cinemas, Copenhagen, Denmark

Collections

	The National Art Foundation
	New Carlsberg Foundation

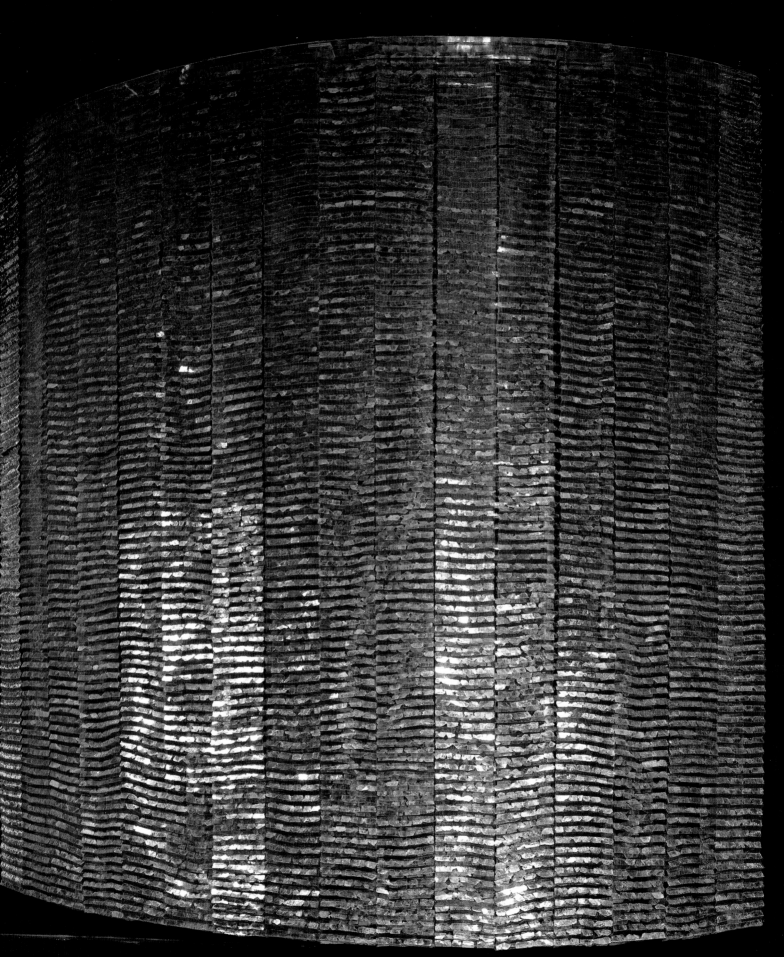

Agneta Hobin

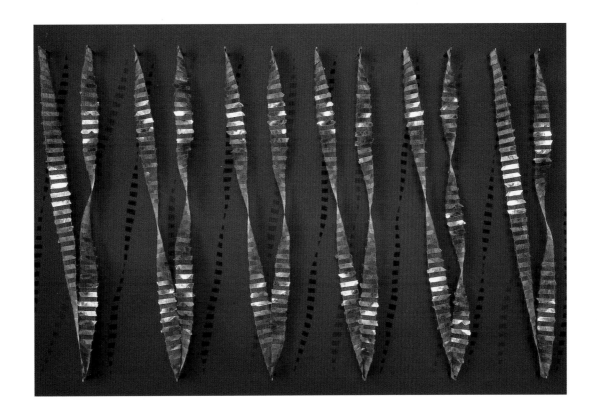

Water, ice, snow, earth, air and light are present in my works

as impressions of the North.

left:
Glacier
1997
mica interwoven in
steel bronze patinated,
pleated
300 x 300 x 50cm

above:
Rocking in the Misty Wind,
Swishing on the Bluish Sea (detail)
2004
mica interwoven with steel, strips,
painted mdf-board
100 x 275cm

During my studies and the first ten years of my career I did textile printing, designing textiles for industrial production. I painted designs 1:1, and loved using soft brushes to mix and spread layers of paint onto the A1-size litho poster paper. At the same time I was also doing some hand-printing. I tried to achieve expressive, loose and organic lines with a brush. My designs were often related to nature: plants, leaves, flowers or branches; one of them is still in production as a wallpaper design at Duro, a Swedish company. Nowadays, the way in which I work is radically different, even though the origin is still images of nature. For several months every year I stay at our country retreat, some 400 kilometres north-east of Helsinki, near to the Russian border. Here I can rest and absorb imprints of nature for future artworks.

The Finns are forest people, and this is particularly true of artists. Water, ice, snow, earth, air and light are present in my works as impressions of the North. Mica, my preferred material, offers means of interpreting natural impressions in an excellent way: it is transparent, dimly shining and simultaneously strong and sensitive. I found mica in an abandoned quarry in western Finland fifteen years ago. I still travel there every summer to gather material. I prepare it by splitting the pieces (about the size of my hand) into thinner and thinner layers and cut these into strips which then are interwoven with steel or bronze in handlooms. The material can be patinated at high temperature to achieve darker nuances. Often I pleat it to form a relief because this catches light more effectively. I like to work three-dimensionally.

It has always interested me to work consistently with themes, developing pieces in different materials and techniques through one form, one theme. Good examples are my tail-like forms or fans. They range from smaller works to pieces five metres high. When I am at the start of a new work, be it a commission or exhibition work, I like to know the proportions of the space.

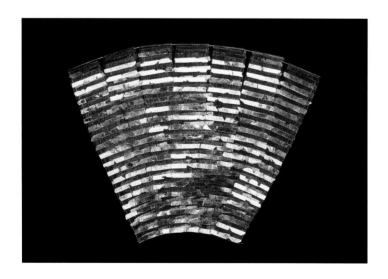

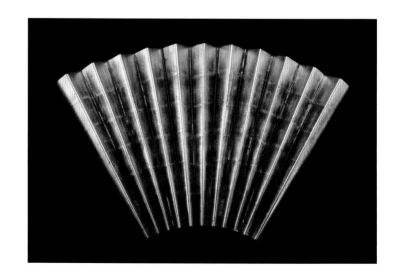

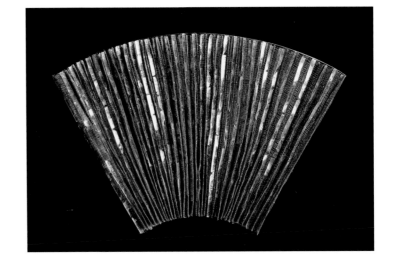

below:
Gloria
2001
wooden relief,
gilded
40 x 66 x 26cm

top right:
Moonbeam
2001
interwoven mica, bronze,
patinated, pleated
40 x 66 x 26cm

near left:
Martyrium
2002
wooden relief, gilded,
gold leaf
40 x 66 x 26cm

right, middle:
At Night
2001
wooden relief, paint,
nail
40 x 66 x 26cm

far left:
Little Moonbeam
2004
mica interwoven in steel
40 x 55 x 22cm

bottom right:
Venetian Blind
2001
lime tree
40 x 66 x 26cm

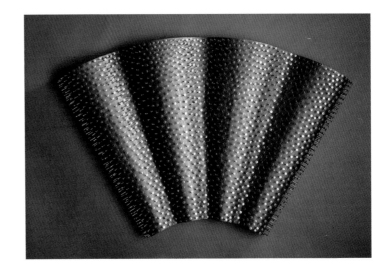

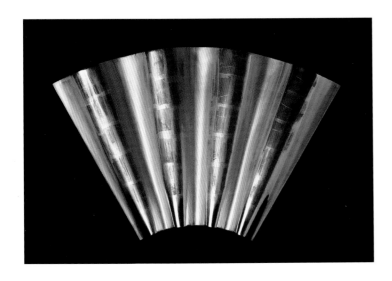

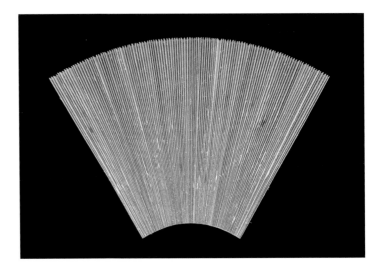

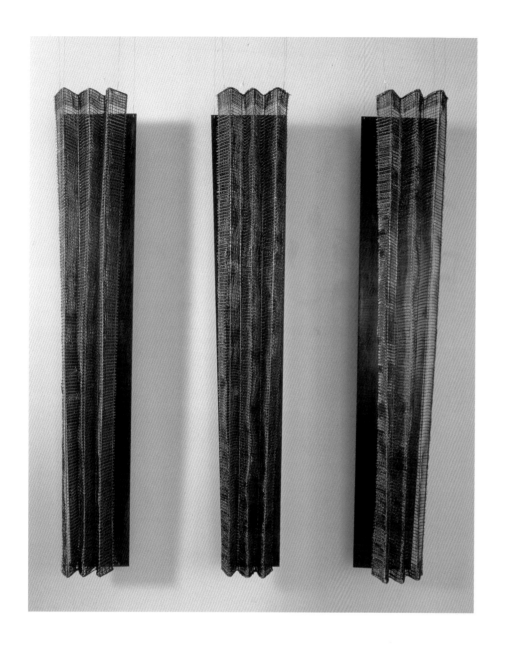

left:
Images of Night, The City
1992
woven, pleated copper and plastic,
steel background, patinated
each 140 x 30cm

right:
**Slipped the Moon from the Stone,
The Day from the Rock**
in collaboration with Ritva Tulonen
1997
mica interwoven with bronze,
patinated, hand-built stone-ware
mica hanging: 100 x 100cm
commissioned by Helsinki Energy

I usually make a maquette of the space and place the sketches there in scale to see how they work together. I actually regard my things as enriching parts of the architecture. It is important to have proportions right, to make the dialogue between the piece and the space work, and to try to achieve the *genius loci,* the spirit of the place. As a result of many years' joint exhibitions, ceramist Ritva Tulonen and I have made two commissions for official buildings together [see right]. We believe the heavy hand-built stone-ware and the light transparent mica-meshes complement each other, creating a good dialogue.

My works involve a collaboration with many others, including cabinet-makers, art weavers, metalsmiths and even gilders. Co-operation is a fruitful area for an artist otherwise working alone.

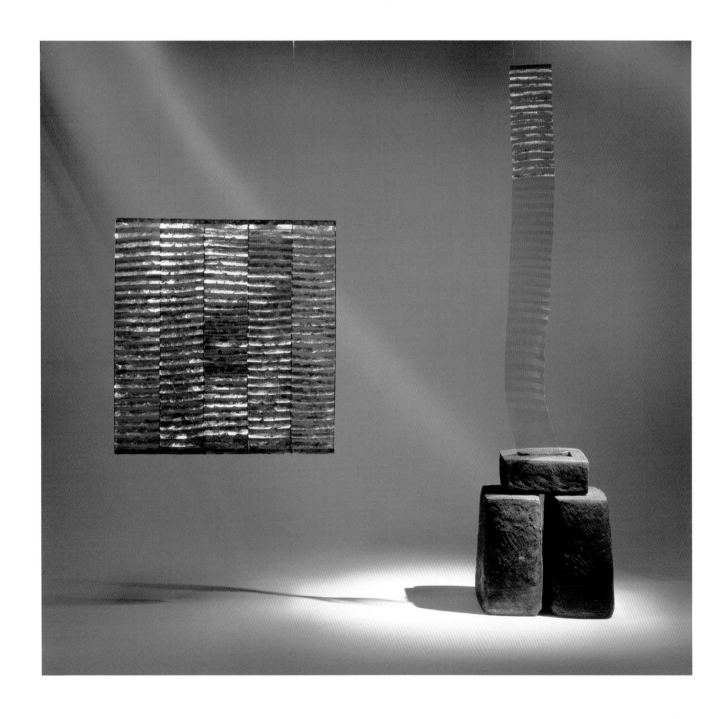

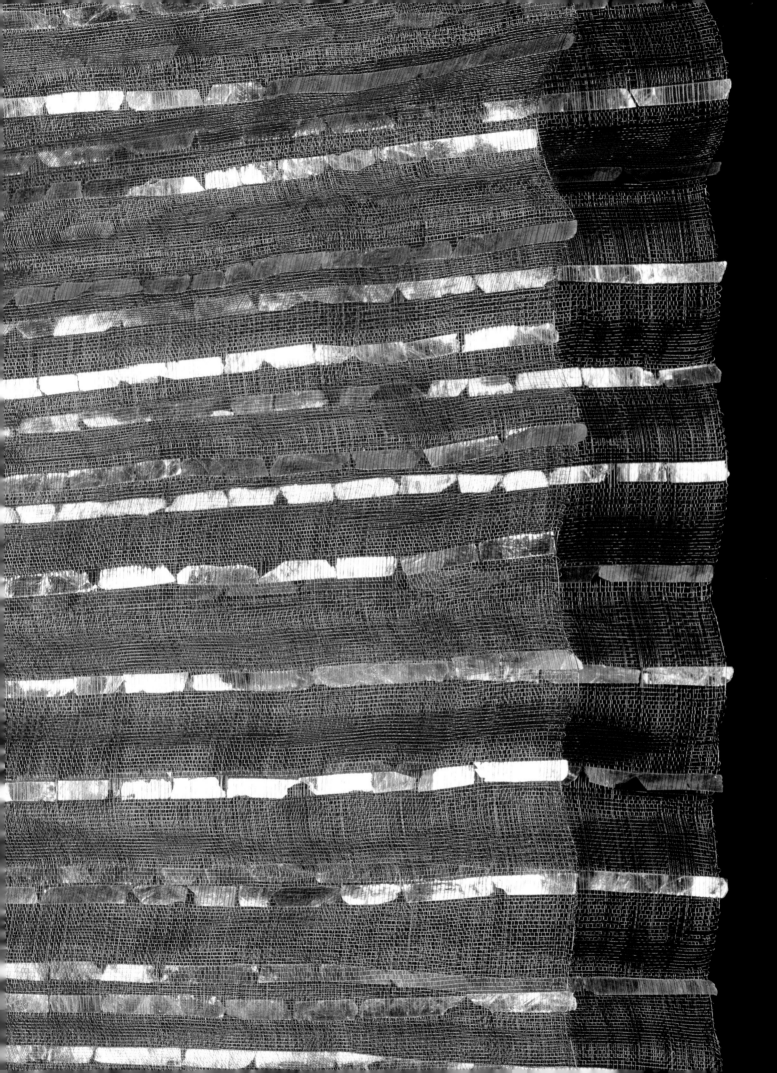

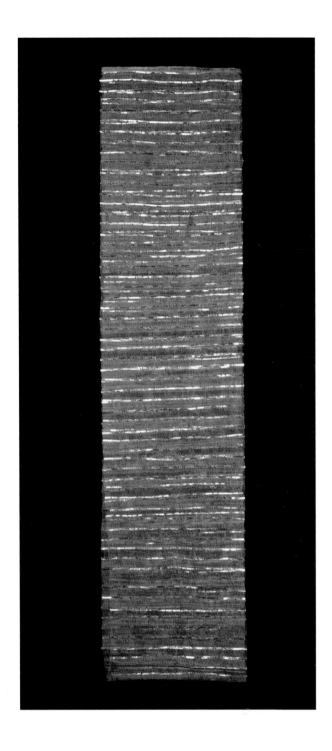

Mica, my preferred material, offers means of interpreting natural impressions in an excellent way: it is transparent, dimly shining and simultaneously strong and sensitive.

Cascade
2001
mica interwoven in steel,
pleated
230 x 80cm

Space, 2
2004
mica interwoven with steel
95 x 60 (diameter) cm

Born	1945, Helsinki, Finland
Atelier	Helsinki, Finland
	www.agnetahobin.fi

Education and Awards

1967-71	University of Arts and Design, Helsinki
1985	1st prize, Competition of Ecclesiastical Textiles, Helsinki
1987	State prize, Arts and Design
1995	15-year state grant
2001	The Nordic Award in Textiles, Fokus Foundation Sweden
2004	Textile Artist of the Year, TEXO, Helsinki
2005	The Bavarian state prize, Munich

Exhibitions

2005	'The Universe of Metal' (solo), Neue Messe München
2004	O-Gallery (solo), Helsinki
2003	The Finnish Institute (solo), Paris
2002	The Finnish Institute (solo), Stockholm
2001	The Textile Museum in Boras (solo), Sweden
	NORRUT, Art Museum ASI (tour), Reykjavik
1998	Art Gallery of Western Australia, Perth
1997	'Winter', Barbican Centre, London
	International Textile Triennale, Tournai, Belgium
1995	Hordaland Kunstnersentrum Bergen (solo), Norway
1988	6th International Triennial of Tapestry, Lodz, Poland

Commissions

Supreme Court, Helsinki
Government Palace, Helsinki
Torstraße 140, Berlin-Mitte
Etera Mutual Pension Insurance Co., Helsinki
Finnish Sports' Federation, Helsinki
Helsinki Energy

Collections

Fokus Foundation, Sweden
Erik Anker Kollektion, Oslo
Design Museum, Helsinki

Ingunn Skogholt

left:
Connection II
2001
woven tapestry
wool, cotton, linen,
synthetic threads
180 x 105cm

above:
Connection III
2002
woven tapestry
wool, cotton, linen,
synthetic threads
180 x 105cm

An artwork should enrich and surprise,
and at the very least should be a source
for a common experience and
a feeling of belonging.

I grew up with the smell of oil paint. My mother used to paint, and I was given art books to look at as a child. At some point I swapped the paintbrush with thread to compose the picture I wished to express. The closeness to the thread through my hands appealed to me, whereas the paintbrush did not inspire me in the same way.

Taking colour as my starting point, ideas begin to take shape at the beginning of what is a long working process that requires all my concentration, determination and patience to see the work through. I split my work into three distinctive phases: the sketches, the yarn dyeing, and the work on the loom.

My preliminary designs can be photo montage, collage, acrylics on canvas, pastels on paper. The cartoon for the most recent work *Wood Divided* was painted in acrylic on a piece of plywood. While applying thin layers of acrylic I discovered patterns in the plywood that I chose to emphasize.

I also produce pastel work as works of art on their own, both to exhibit and as commissions.

When I work on paper it is often in the form of a collage. I collect and keep all the sketches I do. I often attack these again with scissors to obtain new juxtapositions. The final cartoon that I choose as a starting point for a new tapestry must challenge me, both as a composition and as a colour combination, in order that I feel inspired to work further.

The continuation becomes a creative translation process. The sketch for the tapestry might be only one-fifth of the eventual tapestry size. What was before a small detail might gain new significance, and the resulting altered relationships with other parts of the whole may require readjustment.

Composition in Blue
1988
woven tapestry
wool, cotton, linen,
synthetic threads
140 x 310cm

right:
Wondering – for Hugo
1996
woven tapestry
wool, cotton, linen,
synthetic threads
130 x 300cm

My work is a dialogue between the onlooker and their cultural point of view.

My references are often connected to observations in nature, and recall an atmosphere, or the subtle shimmering from a light source into darkness. I am looking for a movement, using the shapes and colour contrast to engage with in a meditative way, hoping to share a memorable image. An artwork should enrich and surprise, and at the very least should be a source for a common experience and a feeling of belonging.

The materials I use are a mixture of threads of different colours and qualities, wound round each other on a bobbin. I surround myself with a huge selection of colours before I start the weaving process. At the end of the day my working can resemble a spider's web of threads crossing each other over the whole studio floor. I colour almost all the yarn I use myself. When I have different qualities of yarn mixed together in a dye bath I obtain different hues of the same colour. The tapestries are made on a vertical frame where I have the opportunity to see all the woven work at any given time. I move upwards with the tapestry work, first sitting on a wooden box and then finally the box is placed on top of a table. For me it is very important to be able to see the bottom corner before I finish the work.

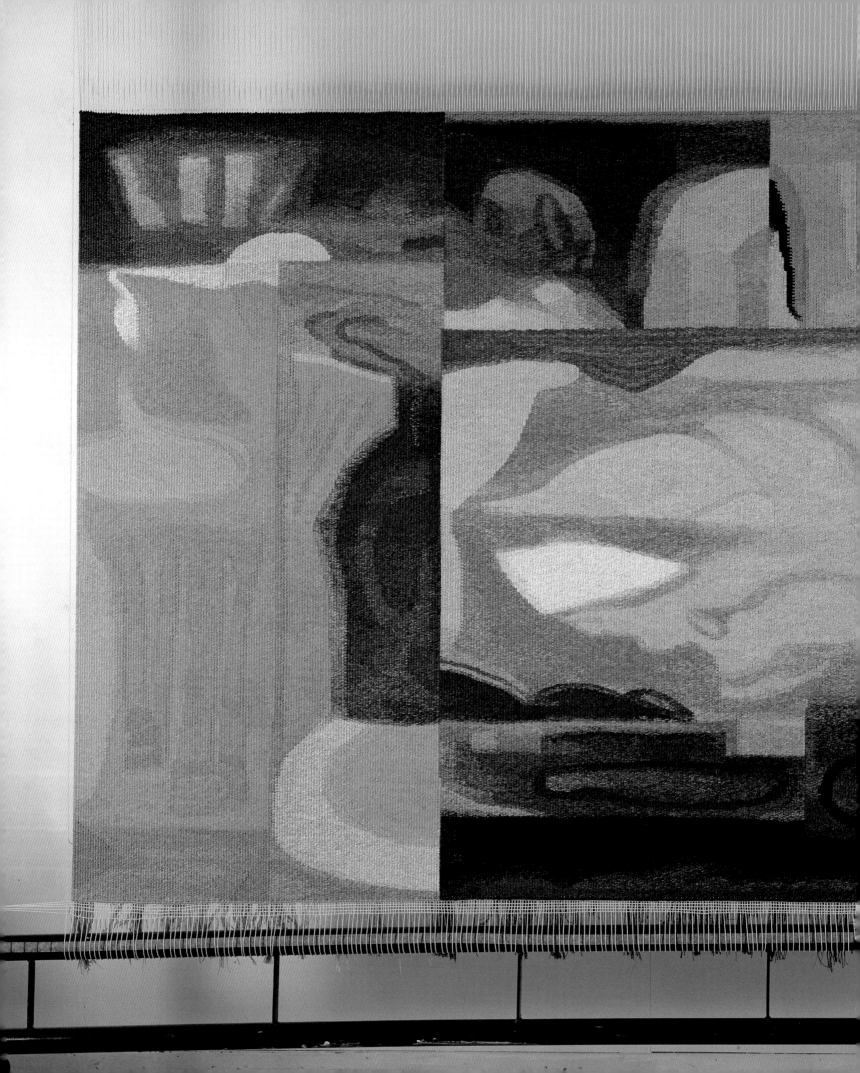

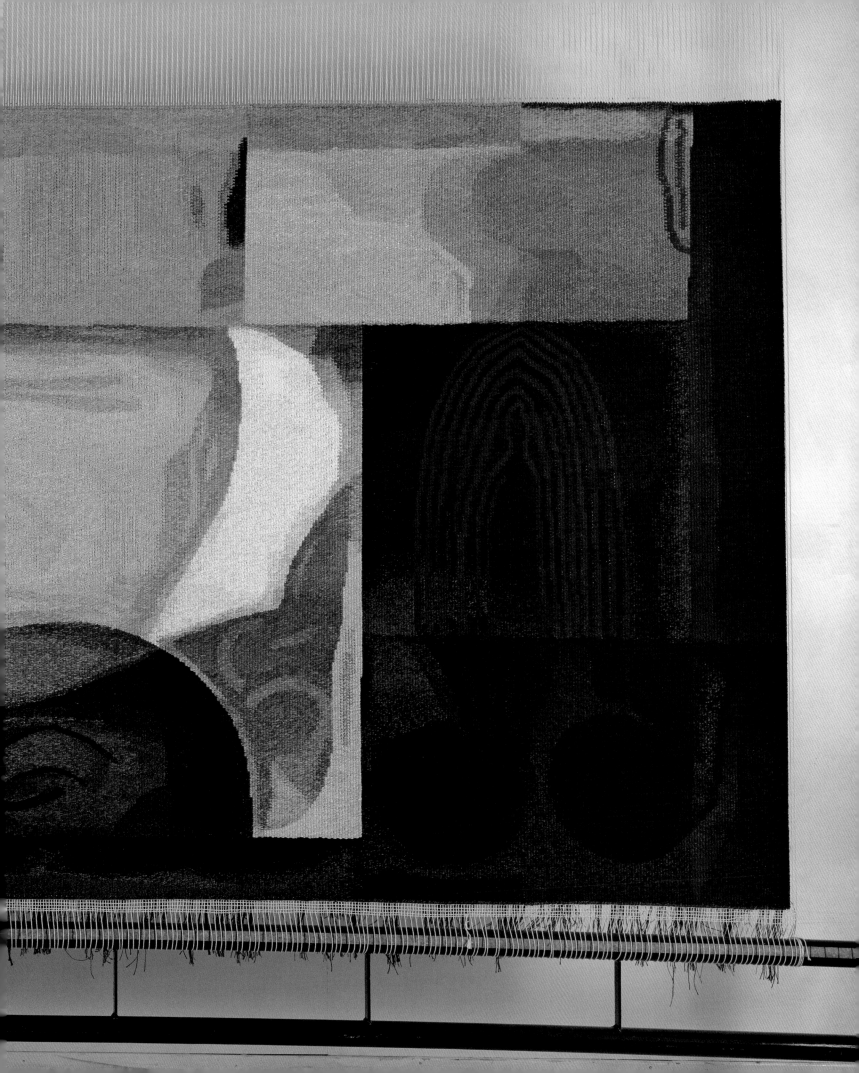

I think about the different Norwegian expressions that tell us about human relationships, using thread as a metaphor. 'There is a red thread' running through, there is a connection. 'To lose the thread', the story is broken. 'To keep close to the thread' has become an important task in a common understanding.

left:
Wood Divided
2004
woven tapestry
wool, cotton, linen,
synthetic threads
180 x 180cm

above:
Wood Divided II
2004
acrylic sketch
on plywood
40 x 40cm

pages 54 & 55:
Becoming
1998
woven tapestry
wool, cotton, linen,
synthetic threads
180 x 350cm

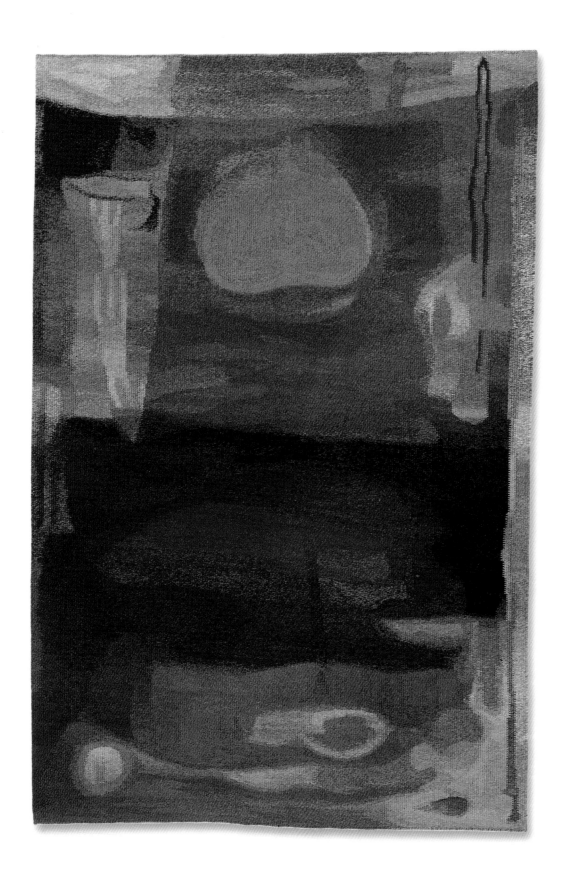

Shimmering Reflection
1995
woven tapestry
wool, cotton, linen,
synthetic threads
190 x 130cm

| Born | 1952, Oslo, Norway |
| Atelier | Oslo |

Education and Awards

1969-73	The National Academy for the Arts, Oslo
1971	Studied Atelier des Gobelins, Paris
1973-74	Art Academy Bratislava, Slovakia
1975-76	Edinburgh College of Art, Scotland, postgraduate year
1977-79	Master of Art, Royal College of Art, London
1979	Drawing Prize, Royal College of Art
1980, 1981,1992	Fine Artist's Scholarship
1988	The Norwegian State's 3-year scholarship
1990	Oslo City Culture Scholarship
1983, 1993, 2002	The Norwegian State's travelling and study scholarship
1999	Guaranteed annual income from the Norwegian Government

Exhibitions

2001	'The Nordic Thread', Nykøbing, Sjælland, Denmark
1997	SAAC, The Royal Scottish Academy, Edinburgh, Scotland
1997	International Textile Triennale, Tournai, Belgium
1996	'Woven Image', Barbican Centre, London
1992	New Norwegian Tapestry Art, Trondheim, Norway
1984-95	Galleri K, Skillebekk, Norway
1976-92	The National Annual Fine Artists Exhibition, Oslo

Commissions

2002	Senior Social Centre, Vinderen, Oslo
2001	Hamar Law Courts
1998	The Norwegian Government Building
1995	The Law Courts, Oslo

Collections

The Norwegian Museum for Contemporary Fine Art
Oslo City Art Collection
Crafts Council, London
Norwegian Arts Council
Private Collections, Norway and UK

Kirsten Nissen

How much repetition is needed for something to be seen as a pattern, and how much divergence can a pattern take before it is no longer seen as a pattern? Does the emergence of the computer as a working tool have any influence on the way today's people see patterns?

Inside the Envelope
1997
woven ramie
230 x 160cm

The meeting between culture and nature is of interest to me, and in my works I often comment on the movements of man in a regulated world. From my earliest production, this was expressed by using signs and patterns which represent man's behaviour: road markings and board games provided motifs for my earlier works.

Patterns represent a certain kind of order, a principle. I am interested in seeing how a pattern is constituted. How much repetition is needed for something to be seen as a pattern, and how much divergence can a pattern take before it is no longer seen as a pattern? What does a present-day pattern look like? Does the emergence of the computer as a working tool have any influence on the way today's people see patterns? What importance does it have in our experience of a pattern that we are finding our way through network structures on the internet, and what influence do the mathematical models of the chaos theories have on present-day understanding of patterns?

Inside the Envelope: The security pattern prevents unauthorised persons from having access to the confidential information which is contained in the letter. It is the irregularity of the pattern that makes up the factor ensuring that the private sphere is not disturbed.

Random: Traditional Danish household linens often have diaper patterns using strict mirroring and repetition of pattern elements. In the Random towel series, these traditional pattern types are varied using a computer to generate arbitrary factors, and thus at one and the same time reflect tradition and modernity.

Kim room 39: The rug was created for a special exhibition at the Danish Museum of Decorative Art, Copenhagen, and is a specific homage to the museum's textiles study collection, where 2000 years of textiles from all over the world are displayed. On a plan of the room with a grid incorporated, I marked the areas which were already covered by textiles displayed. The drawing was then processed in a simple computer program created by John Conway , called "Game of Life". It consists of a grid with cells (black or white) which, based on a few mathematical rules, can live (black), die (white) or multiply (black). Depending on the initial conditions, the cells form various patterns throughout the course of the game.

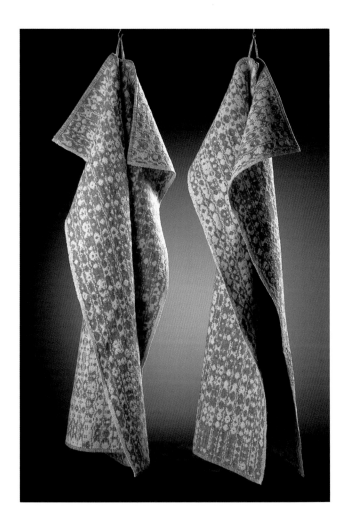

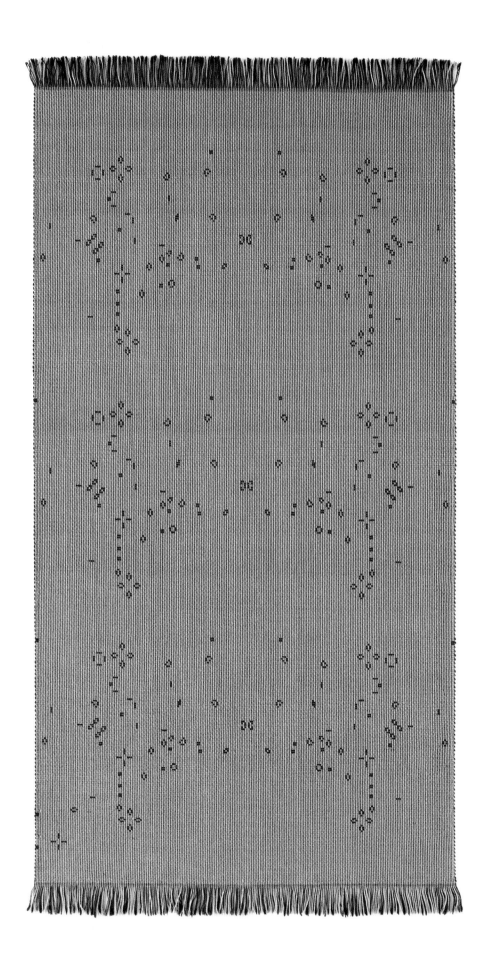

Kim Room 39
2004
woven mohair
300 x 150cm

left:
Random
2001
woven cotton, linen
each 85 x 45cm

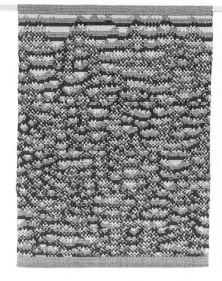
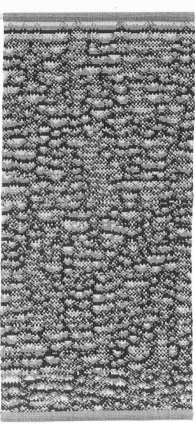

Manual Work
2004
woven polyamide
138 x 315cm

The calculations stop when a stable condition has been reached, and this final state is the pattern of the rug. The composition contains a certain degree of symmetry and repetition, and thus attaches itself to the pattern tradition, but at the same time the composition seems restricted and possibly unfinished. Paradoxically, individual pattern elements have achieved a similarity to traditional knitting and cross-stitch patterns which are represented in the museum collection.

Manual Work attempts to show graphically the condition you are in when you are weaving. The most recent technology is used in an iterative feedback process where measurements taken at the weaver's body are used as input in a pattern generator. The pattern is transferred directly to a digital jacquard loom, where the weaving is done manually as at a traditional hand loom. Thus it is the weaver's reactions to seeing the unknown, patterned material grow gradually on the loom which influence the next items of input to the pattern generator. The experiment has as its result a non-repetitive pattern where variations are unpredictable. This type of pattern has a number of features in common with patterns and structures which we know from nature, such as cloud formations or waves.

Iteration 24 04 04: This work is an example of the way in which I make small individual works for customers with the digital jacquard loom. In this case, important personal dates presented the initial values for the pattern generator. Individual patterns are open to individual interpretations.

Hans Nissen's Field
1989
woven wool, mohair
230 x 160cm

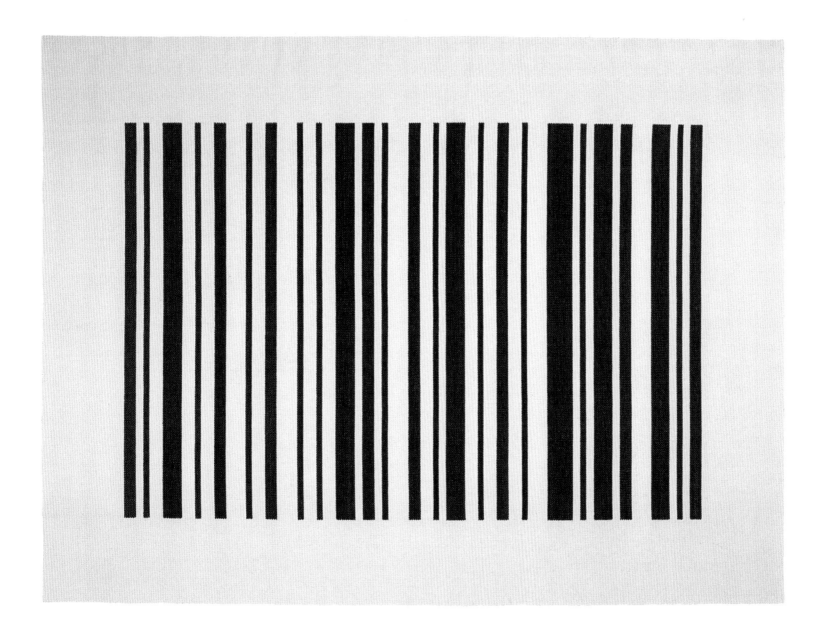

Striped patterns have been used since the beginning of civilisation. At the same time, a modern bar code contains information which human beings are prevented from reading; only machines can read it.

Bar Code
1996
woven ramie
180 x 235cm

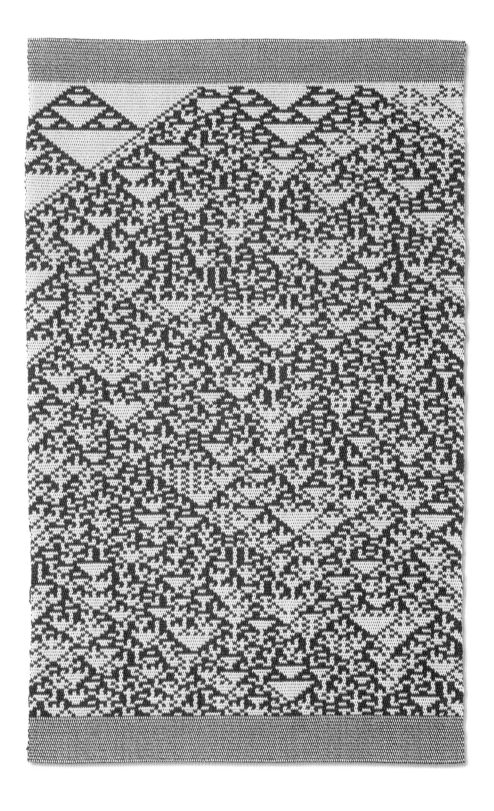

Iteration 24 04 04

2004

woven polyamide

56 x 36cm

Born	1957, Aeroe, Denmark
Atelier	Aeroe, Denmark
	http://homepage.danishcrafts.dk/kirstennissen_uk.html

Education and Awards

1978-84	'The Danish School of Art and Design', Textile Department, Copenhagen
1989	The Copenhagen Polytechnic Art and Craft Prize of 1879, Silver Medal
1990	Hofjuvelerer Poul Michelsens Jubilæumslegat
1996	The Danish Design Fund
1997	3-year grant, Danish Arts Foundation
1998	The Georg Jensen Prize (OCTO)

Exhibitions

2004	'Danish Handmade Rugs', The Danish Museum of Decorative Art, Copenhagen
2004	'Biennalen 2004', Trapholt, Kolding and Nordjyllands Art Museum, Aalborg
2002	'The Tradition of Tomorrow – Innovation in Everyday Life', The Danish House, Paris
1999	'OCTO – form, texture, light', The National Museum of Scotland, Edinburgh
1998	The Danish Arts Foundation, Charlotteborg, Copenhagen
1998	OCTO, The Danish Museum of Decorative Art, Copenhagen
1997	3rd International Triennial, Tournai, Belgium
1997	'Fio2Brazil', Denmark and MASP, Sao Paulo, Brazil
1997	'Tracing Purpose', Leedy Voulkus Gallery, Kansas City, USA
1995	8th International Tapestry Triennale, Lodz, Poland
1990	The Danish Museum of Decorative Art (solo), Copenhagen
1989	'International Textile Competition '89', Kyoto, Japan

Collections

The Danish Museum of Decorative Art
The Danish Arts Foundation

Professional

1992-	Teacher at Designskolen Kolding, The Kolding College of Art, Craft and Design

Publications

2003	*Art Weaving* by Charlotte Paludan, The Danish Museum of Decorative Art
1997	*OCTO*, Rhodos
1996	*Danish Handmade Rugs and Carpets* by Inge Alifrangis
1995	*International Textile Design* by Mary Schoeser

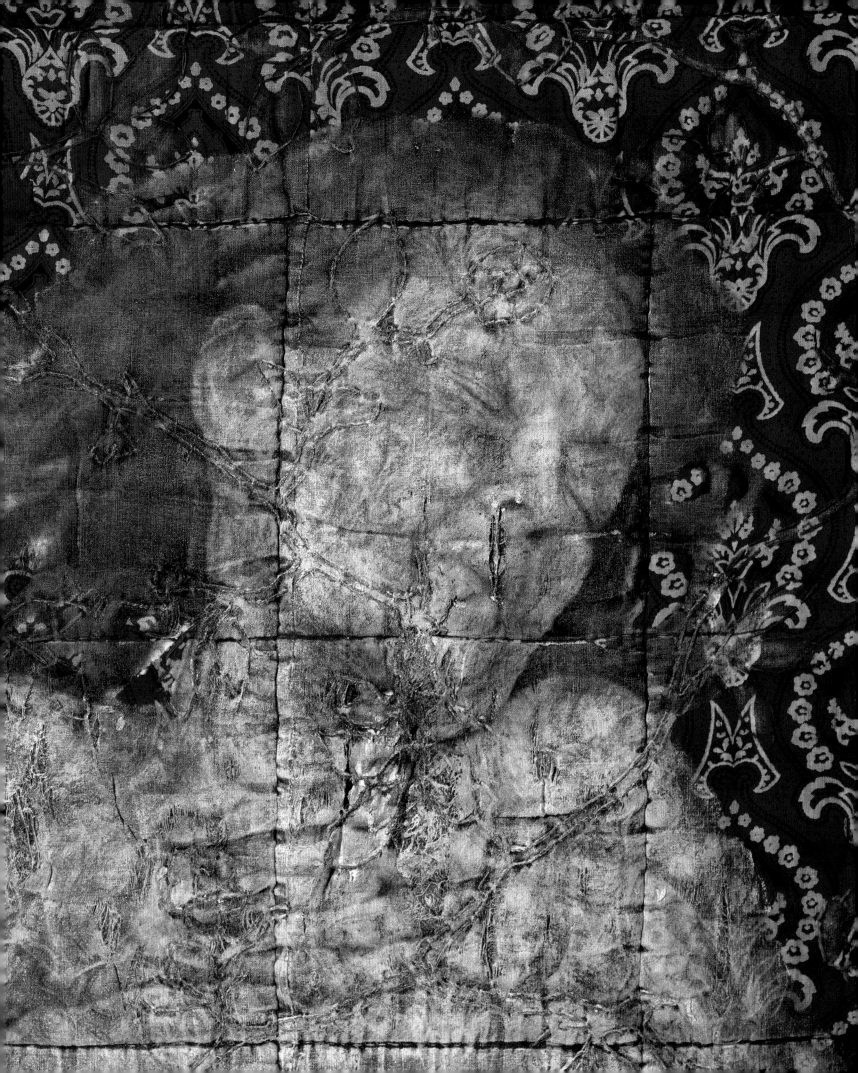

Silja Puranen

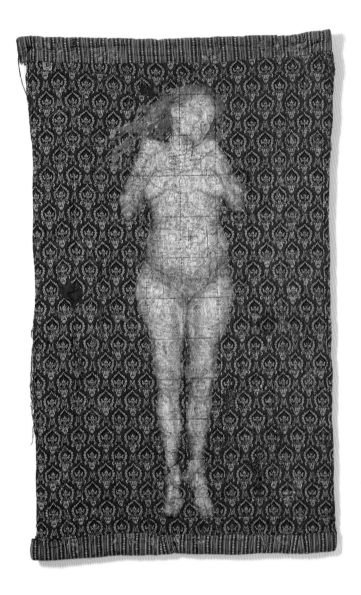

Clothing and other textiles are normally used to cover the body. I use them to reveal what is hidden.

Sleeping Beauty
2003
fabric paint, heat transfer,
soft pastel and stitching
on found textile
190 x 120cm

My first pieces using photographic images were worked out in felting technique. The figurative and narrative features of the photographs enabled me to work on themes and concepts I had had in my mind for a long time without knowing how to express them. I began to work on ideas from a feminine point of view, dealing with a woman's body, sexuality and motherhood. I transferred the photographs onto cotton nappies used by my babies, and onto old lace and so on, which I then felted on the surface of the wool.

Onni (Happiness) from 1995 was a very personal work, its subject being the early days of life of my first son Onni, who has Down's syndrome and congenital myocardial deformation. On a general level the work reminds us about the unpredictability and fragility of life, as well as the many faces of happiness in life.

An important turning point for my artistic work and thinking was *Northern Fibre I* – an international textile art workshop organised by the Finnish textile artists association TEXO. For eight days I worked together with colleagues from various countries. My son Armas was just two-months old, and his cotton diapers served as material for my work.

Looking back, I consider that time to have been the crucible forming my viewpoint as a textile artist: that concept will always go before technique. The textile material is the most essential element, the reason that justifies the work as it is.

In the past, textile art has often imitated other fine arts – weaving or sewing in imitation or representation of painting,

for example. But I resolved to use textiles as an original, irreplaceable material, so that the conceptual outcome could in no way be achieved by any other means.

For the past few years I have been especially interested in the relationship between an individual and the prevalent social norms, for example, how ideals of beauty can be used as a means of exercise of power, a justification for social acceptance or rejection.

The collection I made for my solo exhibition *Presentable to Society* (2004) deals with ideals of beauty. The ideal shape of the female body in so-called civilized cultures has generally been unnatural, impossible to obtain without considerable stress, physical pain and hunger. Yet attaining this ideal has been considered a virtue and the precondition for social

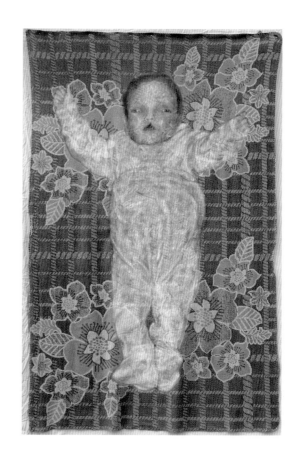

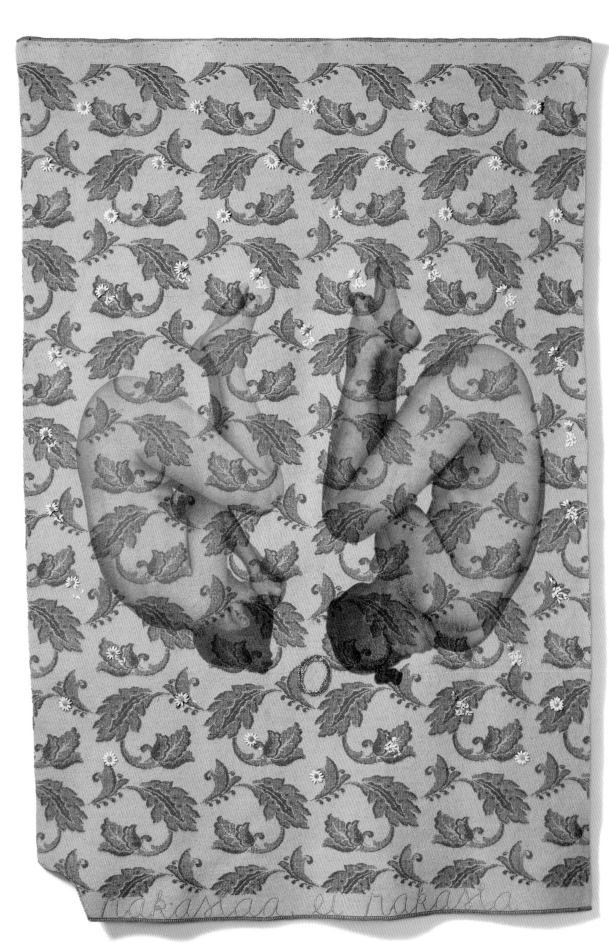

Double Bed
1999
heat transfer,
embroidery etc.
on found textile
216 x 142cm

left:
There is a Difference
('A Matter of Change' series)
2005
fabric paint, heat transfer
and soft pastel on found
textile
204 x 139cm

appreciation, whilst not achieving it shows weak discipline or even moral inferiority. Today, extreme thinness has become the pre-eminent ideal of beauty, and as a result more than one generation of women in the western world has lost any natural relationship to eating.

The most recent collection I'm working on questions the aim of the contemporary, medicalized and technocratic society to control the process of life from the moment of conception (or before) all the way to the grave. Life has been reduced to a kind of supermarket where you can choose the goods to your liking. But are there any issues of decency and limitation beyond which we shouldn't go? Is there any role for mere chance or fate? What if the unexpected happens? In this collection I have worked on photographs of my early childhood, manipulating them to show congenital deficiencies, disabilities and syndromes; transferring them onto adult-size bedspreads; giant babies who question their right to exist.

The second-hand textiles sourced from attics and flea markets bear their own personal (and often unknowable) histories, adding another layer of significance to the work. Clothing and other textiles are normally used to cover the body. My work reveals what is hidden; vulnerability is exposed through the transferal of photos onto patterned textiles, making the figures melt into the background, while still revealing it.

For non-white textiles I have developed a method of painting the fabric so that the image does not entirely fade to the background, yet it is still translucent. In some pieces I also use embroidery to bring temporal or spatial layers to the work. In my latest works I have manipulated the original photographs to underline the gap between the ideal and the reality. I use myself as the model for the original photos: besides being a practical arrangement, it symbolizes the contradictory requirements to be met by an individual.

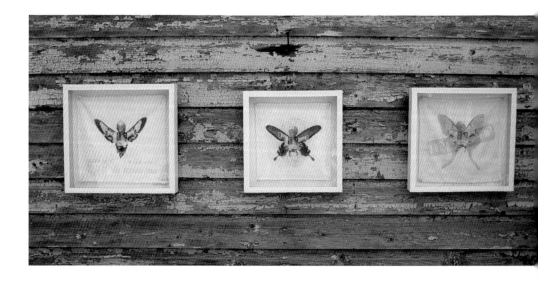

Butterfly Collection
2001
heat transfer and embroidery
on found textile, insect pins
38 x 194 x 5cm

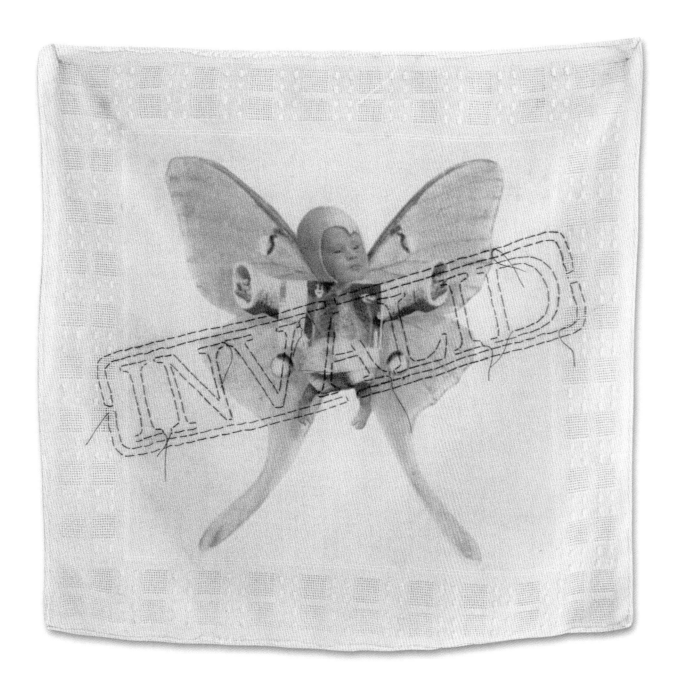

Vulnerability is exposed through the transferal of photos onto patterned textiles, making the figures melt into the background, while still revealing it.

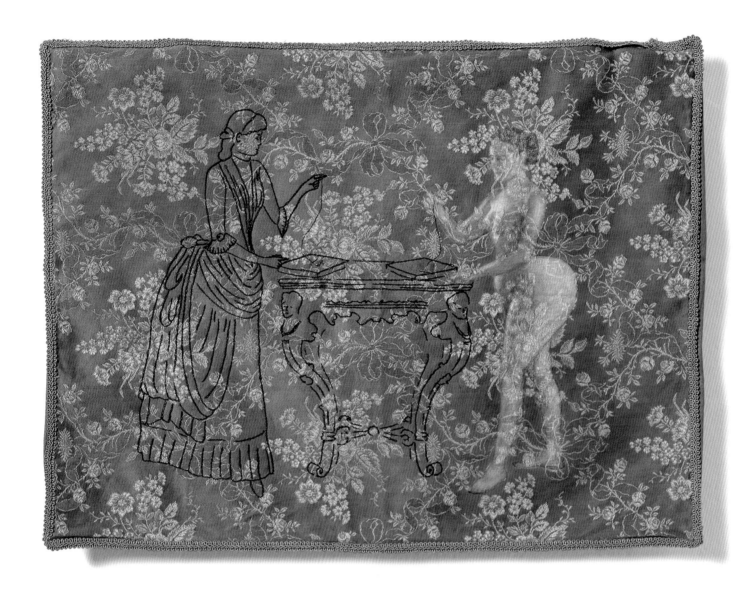

Tournure 1885

('Presentable to Society' series)

2003

fabric paint, heat transfer,

crayon and embroidery

on found textile

39 x 52cm

right:

I Could Have Danced All Night

2003

fabric paint, heat transfer

and soft pastel

on found textile

180 x 147cm

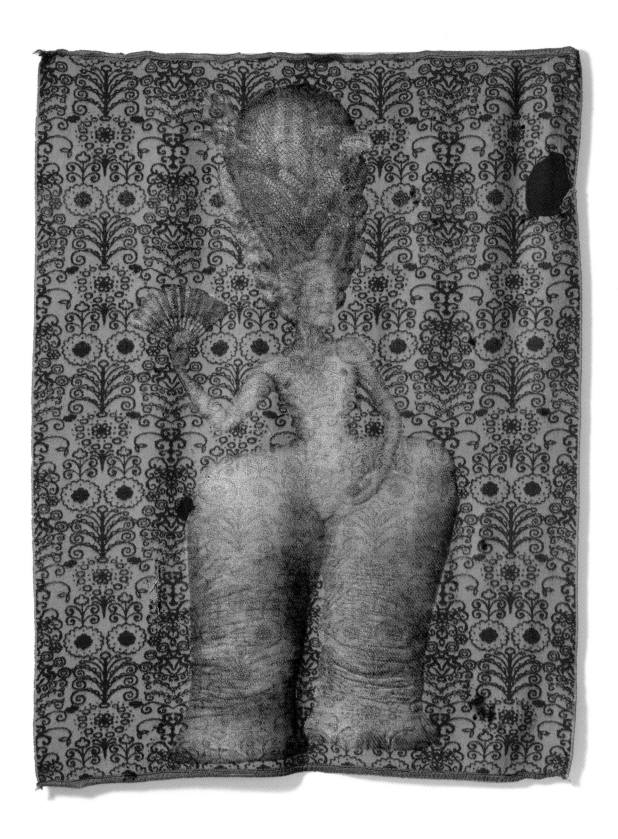

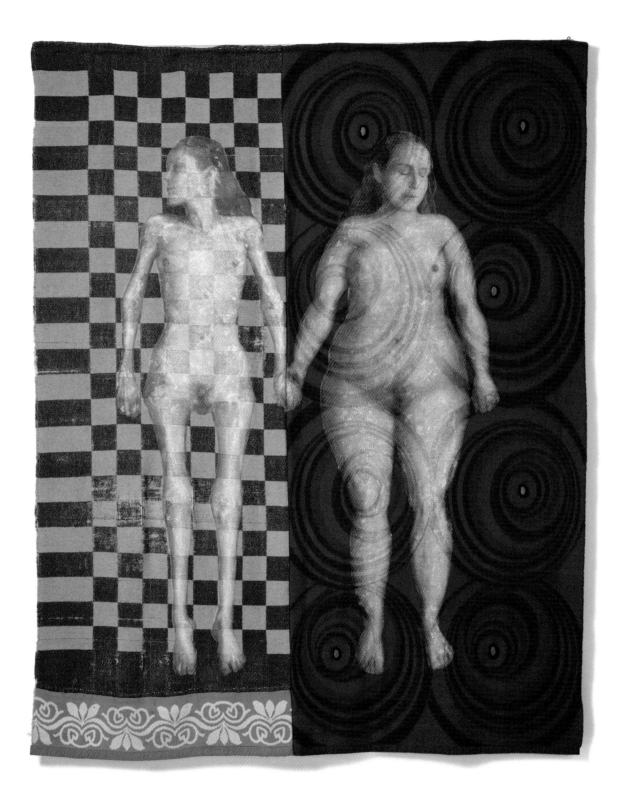

Renunciation and Lapse

2003
fabric paint, heat transfer, soft
pastel etc. on found textile
218 x 178cm

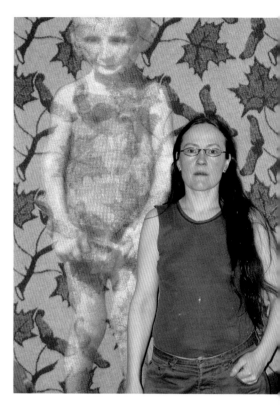

Born	1961, Elimäki, Finland
Atelier	Järvenpää, Finland
	www.siljapuranen.com

Education and Awards

1987	Kuopio Institute of Art and Design, Textile designer
2000	University of Helsinki, basic studies in aesthetics
2000	WCC-Europe Award for Contemporary Crafts
2003	4th International Textile Art Exhibition, Kaunas (LT), 3rd prize

Exhibitions

2005	Turku Biennial 2005, Ars Nova Museum, Turku, Finland
2004	'Apta pel saló' (solo), La Galeria, Barcelona, Spain
	2nd European Triennial Textile and Fibre Art 'Tradition and Innovation', Riga, Latvia
	4th Fibre Art Biennial 'Trame d'Autore', Chieri, Italy
2003	4th International Textile Art Exhibition 'Right and Wrong Sides', Kaunas, Lithuania
2002	'Masterpieces', Turin, Italy
2000	5th International Betonac Prize Competition, Sint-Truiden, Belgium
2000, 1997	Finnish Artists' Annual Exhibition, Helsinki Kunsthalle, Finland
1999, 1995	'Northern Fibre 1 & 3', Voipaala Arts Centre, Finland; Textilforum, Herning, Denmark,
1997	3rd International Textile Triennial, Tournai, Belgium
1996-97	FLEXIBLE 2 Pan-European Art, Tilburg, Netherlands; Wroclaw, Poland; Manchester, England
1994	Fictive Souvenirs (solo), VANTAG, Oporto, Portugal
1992	3rd International Textile Competition, Kyoto, Japan

Collections

	The State Art Collection, Finland
	Art Museum of Oulu, Finland
	Helsinki City Art Museum, Finland
	Cultural Department of the Piedmont Region, Italy
	Musée du Feutre, Mouzon, France

Professional

2004-06	Chairman, Textile Artists TEXO, Finland
2005	Curator for TEXTILE 05 International Textile Art Biennial, Kaunas, Lithuania
2004	Jury member for Northern Fibre 6 workshop and exhibition, Finland

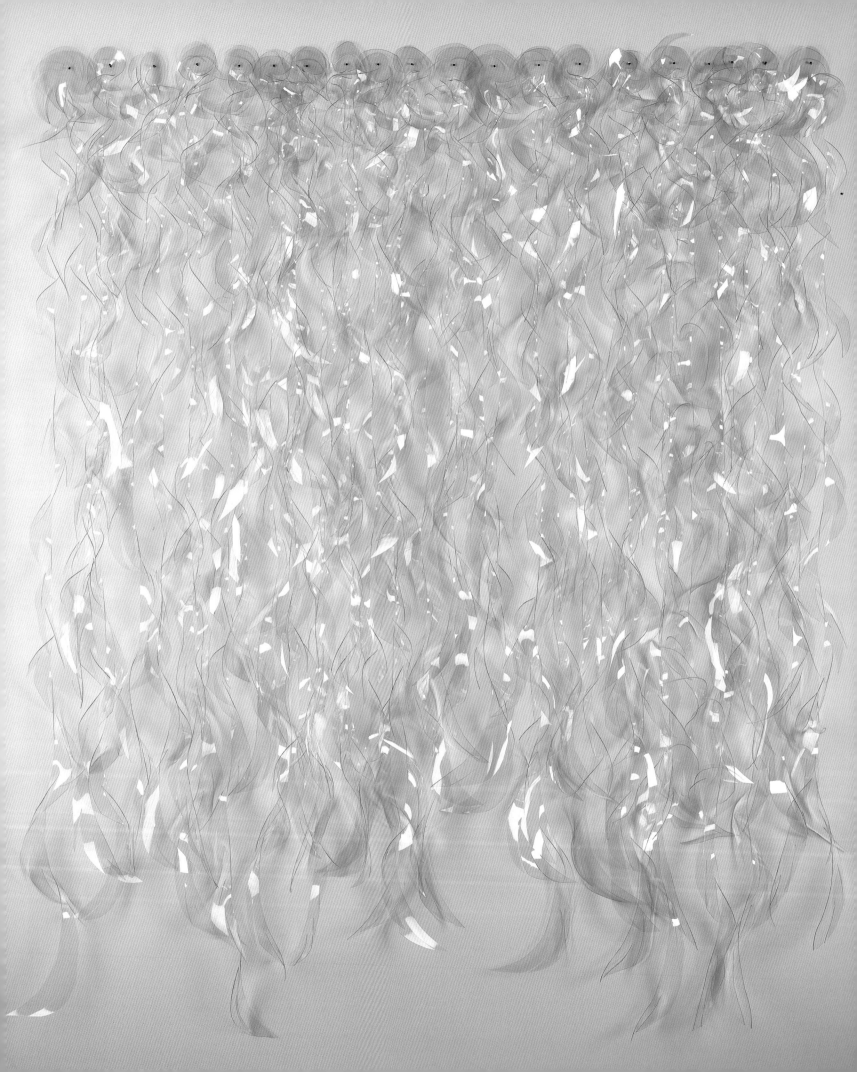

Gudrun Gunnarsdottir

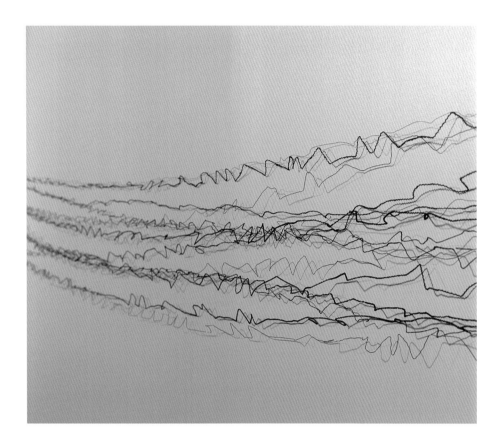

*Every day is a new poem with new letters that become words
and end up as a piece of art that is entangled by threads,
knots, cuts and enormous joy.*

left:
Clear Water
2005
own technique
polyethylene
130 x 110 x 8cm

above:
My Country
2000
own technique
wire
60 x 800 x 10cm

I work with the line, the thread, the invisible, what's not there and what lies inbetween. The thread has always been very important to me. I started as a weaver and did a lot of tapestry work but after ten years of weaving I started to experiment with different materials and techniques. I have tried many different kinds of materials but primarily I use thread, mostly wire, paper thread, plastic, or, if the thread does not exist, I make one that serves my purposes.

I have a nice studio in my house where I have a good wall space. I mostly work directly on the wall, use the wall as a piece of paper, make sketches with materials, try out, throw away, start again dissatisfied, start again – and it sometimes works out; at other times it is just an excercise of thoughts, forms and materials.

The concept of my work is mostly related to nature. It used to be related to the visual impact of nature, but today I am mostly telling a story about nature in decline. Rivers, flowers, moss, sea, fish... one day it may all disappear. I am making a kind of

abstract, visual poetry about nature. What interests me most is what happens in between the lines: forms, shadows, what is hidden and cannot be seen.

My works are mostly three-dimensional; some are like three-dimensional drawings and not built on any handicraft tradition. I make up my own technique as I go along, according to what suits my work at that time.

Very often I make a lot of components; by assembling them I then make a single large work. I make installations and activate the space.

Colour has always been very important to me. I see life in colours and live by colours. Even though I mostly work in black wire since I stopped weaving, this often reflects colours on the wall, by means of the light that falls upon it. I like the shadows, and the way that natural light plays with my works. It multiplies the effects on the wall.

Working as an artist is a way of life. Day and night one is aware of the work ahead, the work that has not been done and maybe never will be. Every day is a new poem with new letters that become words and end up as a piece of art that is entangled by threads, knots, cuts and enormous joy.

Algae VIII
1996
own technique
rubber and wire
25 x 25 x 20cm

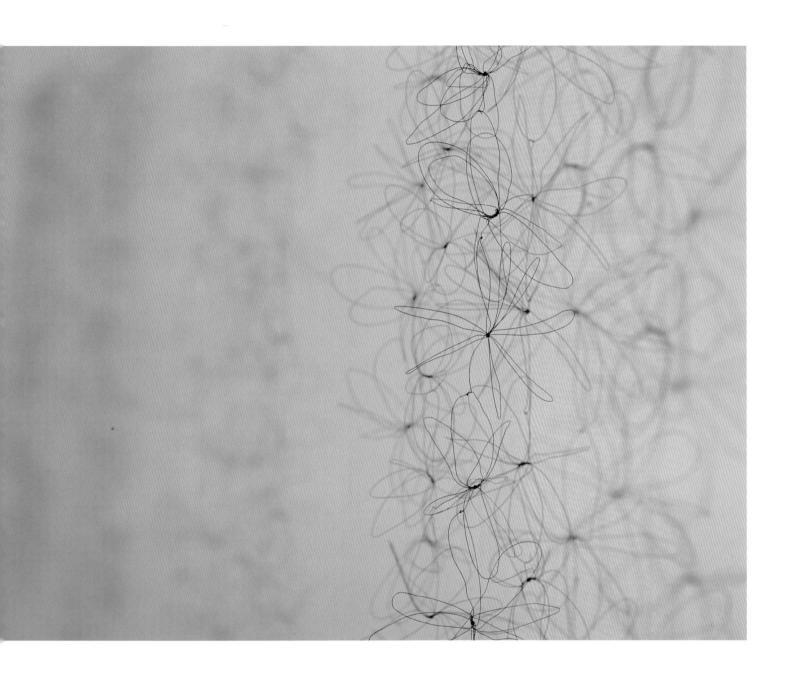

Quadruple (detail)
2003
own technique
wire
4 pieces, each 100 x 90 x 7cm

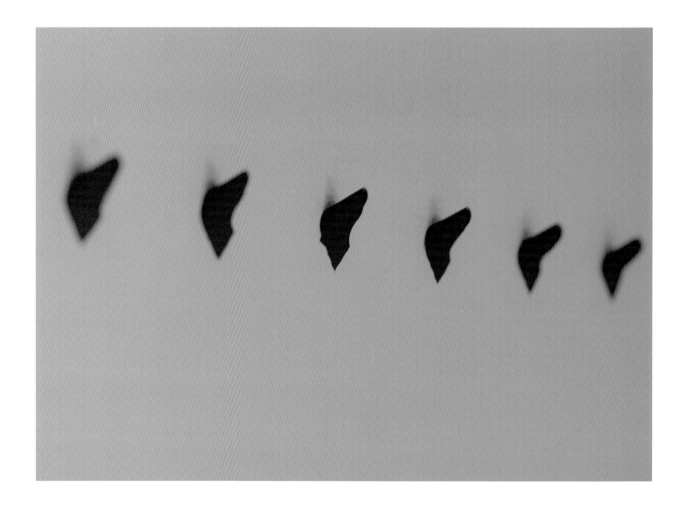

right:
**What There is Left /
Not a Waterfall**
2003
own technique
wire/paper thread
and acrylic paint
110 x 1200 x 14cm /
310 x 700cm

above:
Secrets (detail)
2003
own technique
textile tape
4 x 1000 x 3cm

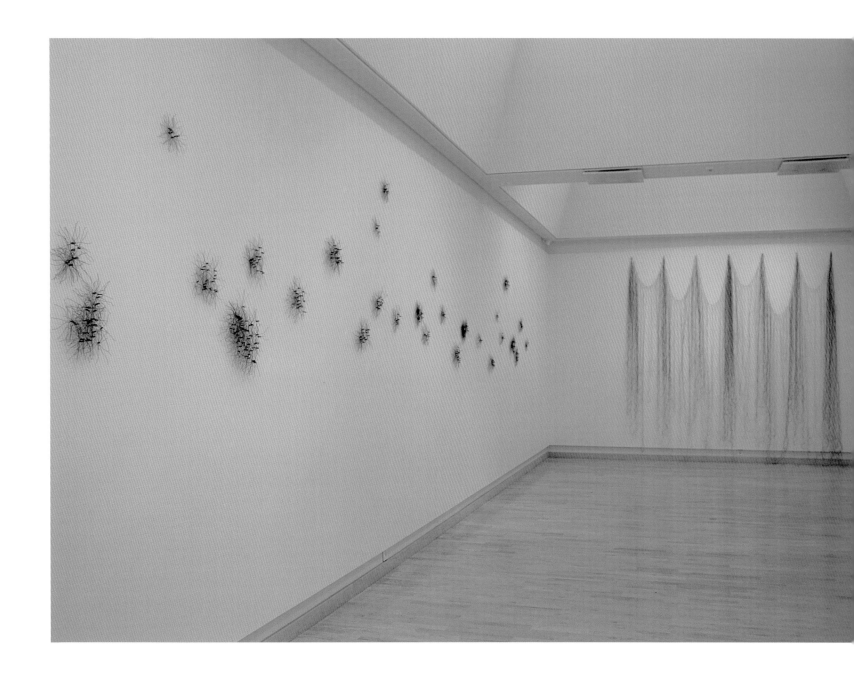

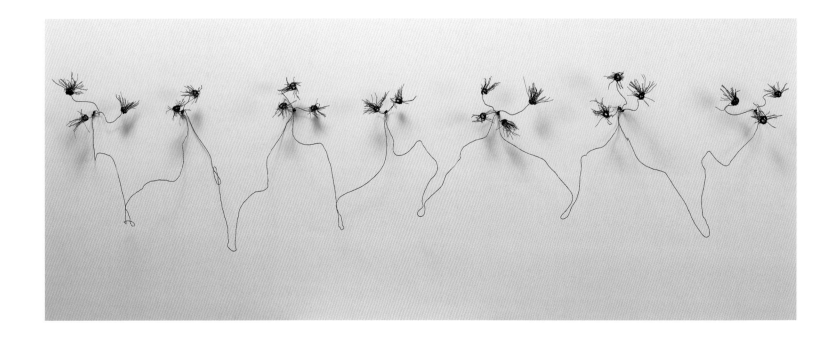

What interests me most is what happens in between the lines:

forms, shadows, what is hidden and cannot be seen.

Flora Islandica?
2005
own technique
wire
35 x 125 x 7cm

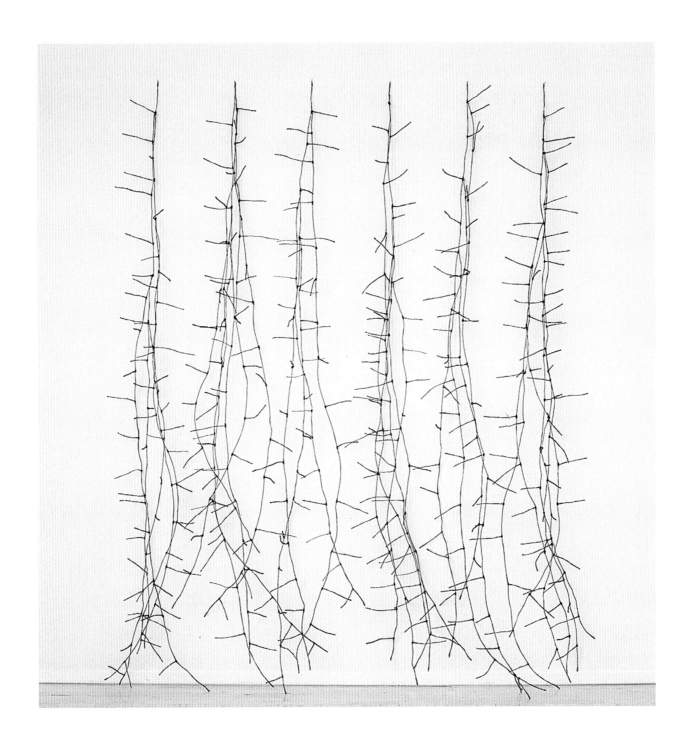

Nature Drawing II
1998
own technique
wire
300 x 250 x 30cm

Written on …
2005
own technique
silk
90 x 260cm

Born	1948, Borgarnes, Iceland
Atelier	Reykjavik, Iceland
	www.internet.is/gudgunn/

Education and Awards

1972-75	Kim Naver's Studio, Copenhagen, Denmark
1987	Haystack Mountain School of Art and Craft, Maine, USA
1998-2003	Various salary grants, Icelandic Government, Reykjavik
1999	City of Reykjavik Artist Grant

Exhibitions

2004	Handicraft Museum (solo), Blonduos, Iceland
	'Transform', Design Islandais, VIA, Paris
	'Nordic Cool', National Museum for Women in the Arts, Washington DC, USA
2003	Kopavogur Art Museum-Gerdarsafn (solo) Kopavogur, Iceland
	The Nordic Cultural Centre Thorshavn, The Faroe Islands
	'The Spirit of Materials', The Art Centre Silkeborg Bad, Silkeborg, Denmark
	'The Icelandic Expressions', CityScape Art Gallery, North Vancouver, Canada
2002	'Reyfi' in collaboration with Anna Thora Karlsdottir, Gallery Skuggi, Reykjavik
	'Crossing the Border: The Other Europe', Morley Gallery, London
2001	Art Museum ASI, Asmundarsalur and Gryfia (solo), Reykjavik
2000-01	'Norrut' Contemporary Nordic Textiles:
	Art Museum ASI, Reykjavik; Bryggens Museum, Bergen, Norway; Museum of Art and Design, Helsinki, Finland;
	The Nordic Embassies, Berlin, Germany; The National Gallery of Fine Art, Kaunas, Lithuania
1999	Contemporary Textile Art, Rovaniemi Art Museum, Rovaniemi, Finland
1998	Art Museum ASI, Asmundarsalur (solo), Reykjavik
1998	Mino Paper Art Museum, Mino, Japan

Collections

The National Gallery of Iceland, Reykjavik
Reykjavik Municipal Art Museum, Reykjavik
Art Museum ASI, Reykjavik
Toyama Design Centre, Toyama, Japan
Mino Paper Art Museum, Mino, Japan
Savaria Art Museum, Szombathely, Hungary

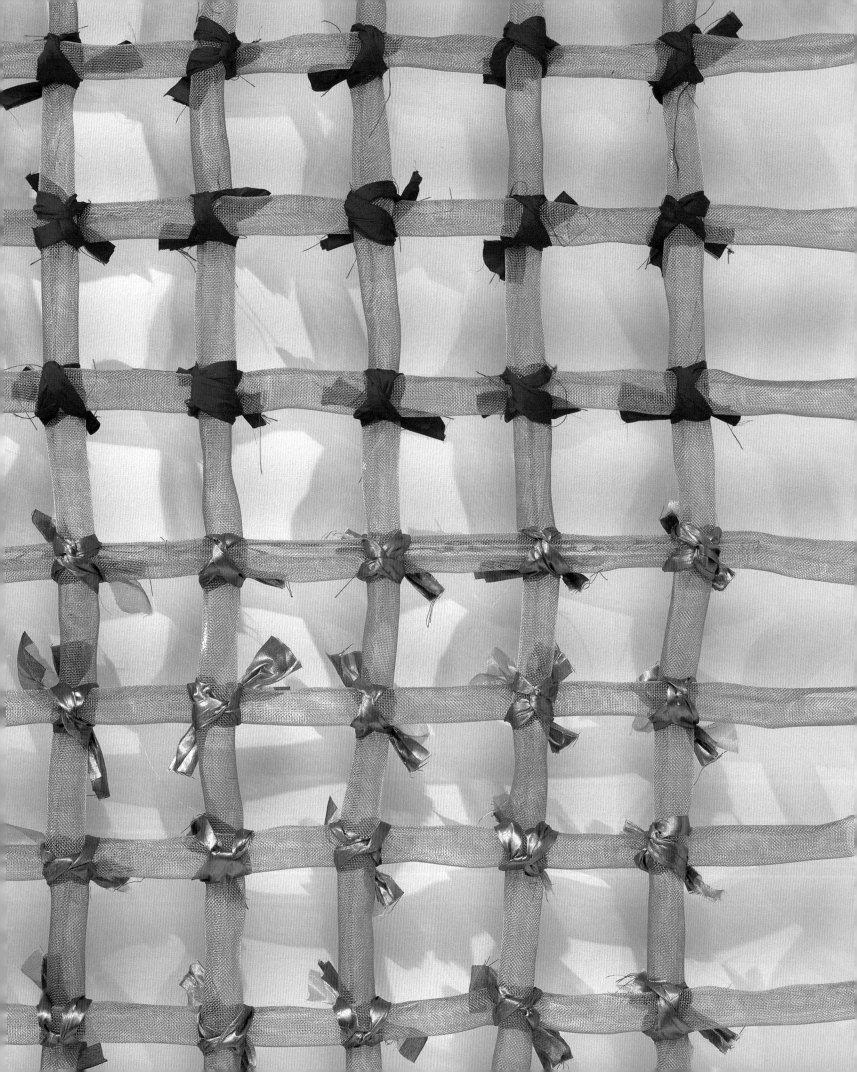

Maija Lavonen

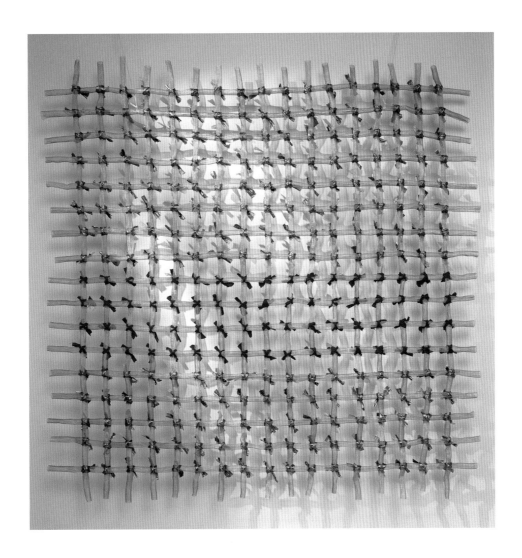

Memories of experiences of nature, powerful visual

impressions, and things experienced as a child,

these are the underlying forces behind my works.

Ties
2002
metal mesh, cloth ties
190 x 190cm

Memories of experiences of nature, powerful visual impressions, and things experienced as a child, these are the underlying forces behind my works. As a child, the world seemed wide open, just starting to expand. The strength of these experiences I have attempted to transfer through my vision to my work.

I started to weave in 1959, when we lived in Kotka, where I was a teacher at a craft school. At art school in Helsinki I had learned the theory of weaving, but in Kotka I started to work myself, designing and making textiles for the home at first, then extending this to art textiles hanging freely from the wall.

In 1970 my husband passed away. I had to take full responsibility for bringing up our two children. In the same year I had my first solo exhibition with large double-weavings, which you could put on the bed or hang on the wall. The material was wool and linen. In this exhibition there were also experimental woven textiles with plastic strips and coloured electric wires woven together with thick wool. I hoped that people would be able to relate to the exhibition.

In 1977, when I started with *rya*-rugs, the material was wool. The only colours were grey and black. Afterwards I broadened my colour palette. The *rya*-rug technique is our old Finnish traditional technique. Later I broke with tradition and added new materials to the wool, such as dyed sisal and sometimes plastic pieces to give contrast to the soft wool, sometimes also painted metal pieces, painted sculptural parts. I also began experimenting with fibre optics in 1977. It is a new and interesting material to me. I try to look for luminous objects. Perhaps my favourite piece is *Path* [see page 96], a *rya*-rug with three stones which I found in the forest. For me *Path* is a meditative work. The other work important to me is the tapestry *Haukivesi*.

I have woven works out of metal mesh, the first of these being in 1983. I use metal mesh as an image of contemporary industrialism and computer networks, but I bind the pieces together by hand, often using silk cloth. I seek out a link between handwork and industrialisation – I want to soften hard values.

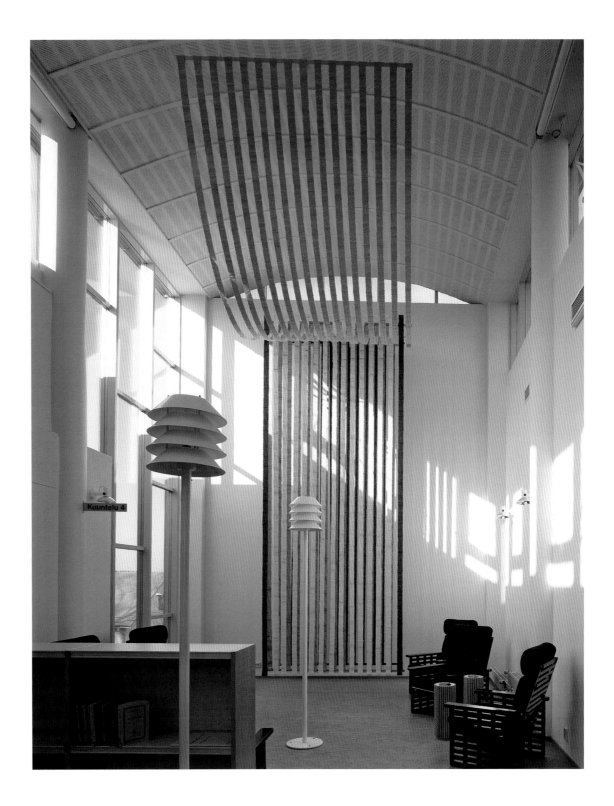

Haukivesi
1985
tapestry and metal elements,
linen, raw silk, burnished
painted steel, elements
for hanging
650 x 220 x 550cm

left:
Light Structure
1987
metal mesh, fabric, natural
and synthetic silk
240 x 240cm

In Finland we are fortunate to have many opportunities to work on the furnishing of public spaces, and on spatial problems.

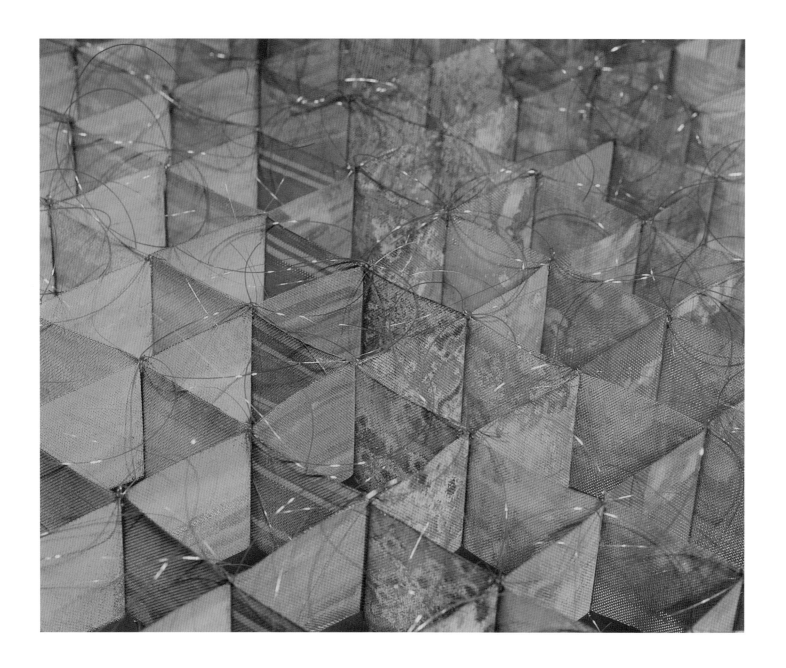

pages 94 & 95:
Voyage (2001)
installation in Meditation Space,
UNESCO headquarters, Paris
oxidized copper mesh bent
and tied into shape with line,
plywood, sand
each quarter 50 x 50 x 5cm
single element 0,5 x 20 x 22cm

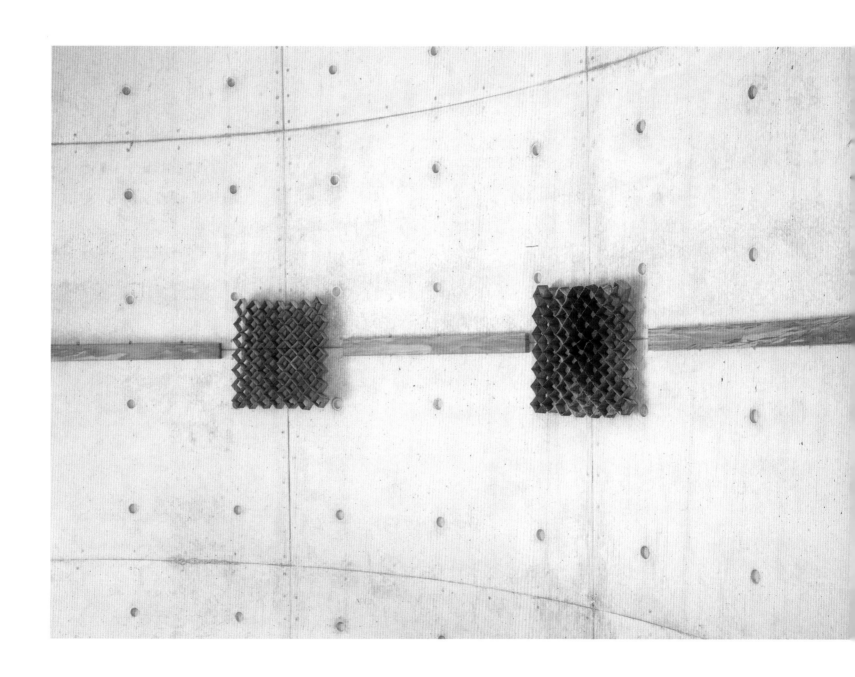

I use metal mesh as an image of contemporary industrialism and computer networks,
but I bind the pieces together by hand. I want to soften hard values.

In 1991-97 I did a lot of painting; I exhibited them in 1992 at Tampere, Pynnikinlinna, and in 1993 in Helsinki, at the Amer Gallery, in addition to several group exhibitions.

I paint on a large scale, sometimes two and a half metres square, on cotton material using pigment paste. In my latest work I have approached the idiom of free visual art. The free painterly expression has become important after earlier monumental and geometric compositions. The expression is still based on a feeling for nature, but also one's inner mentality has gained more significance. In painting, the contact with the work is direct and rapid, without the ponderousness and distancing effect which equipment carries with it.

Nevertheless, the *rya* technique has been the one with which I have felt the greatest affinity: in *rya* I experience temporal depth. A *rya* serves both as textile art and as functional object – both potentials are enormous and of equal worth. In my latest *ryas,* wool is combined with acrylic components. The industrial plastics reach out to tomorrow. New synthetic materials are constantly being developed and are gradually becoming familiar to us. Respect for experiences of nature is paralleled by the emotion evoked by colour symbolism.

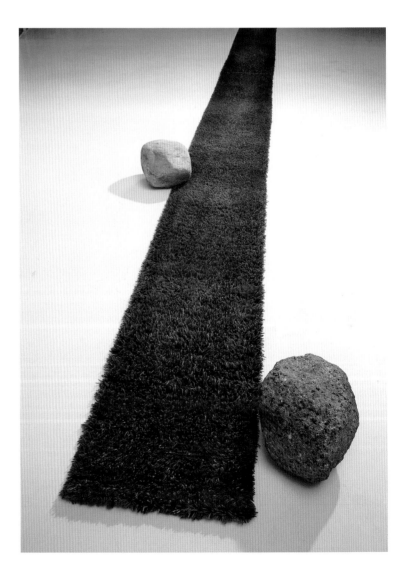

Path
1983
rya wool, three stones
from nature
1050 x 45cm

far right:
Spring Light
1999
rya-rug, wool, linen and
clear pieces of acrylic
225 x 250cm

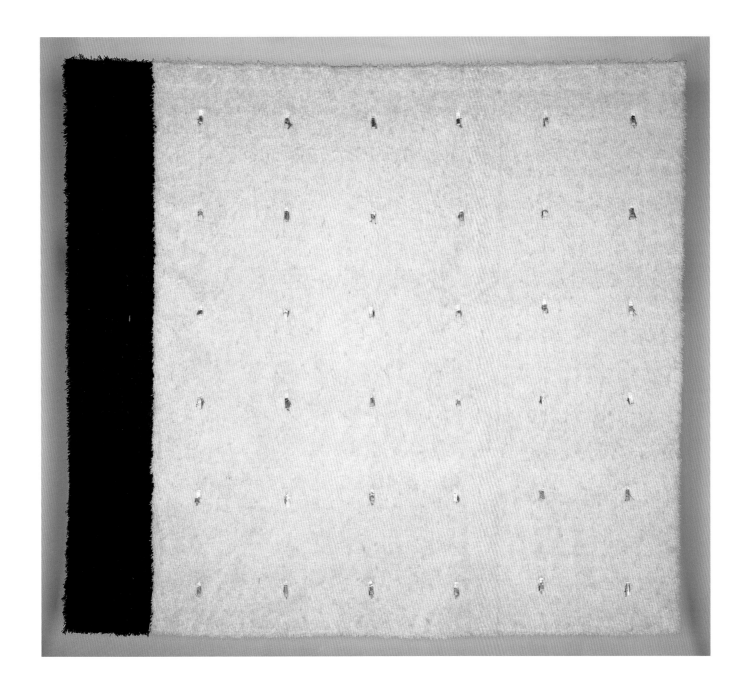

A rya serves both as textile art and as functional object – both potentials are enormous and of equal worth.

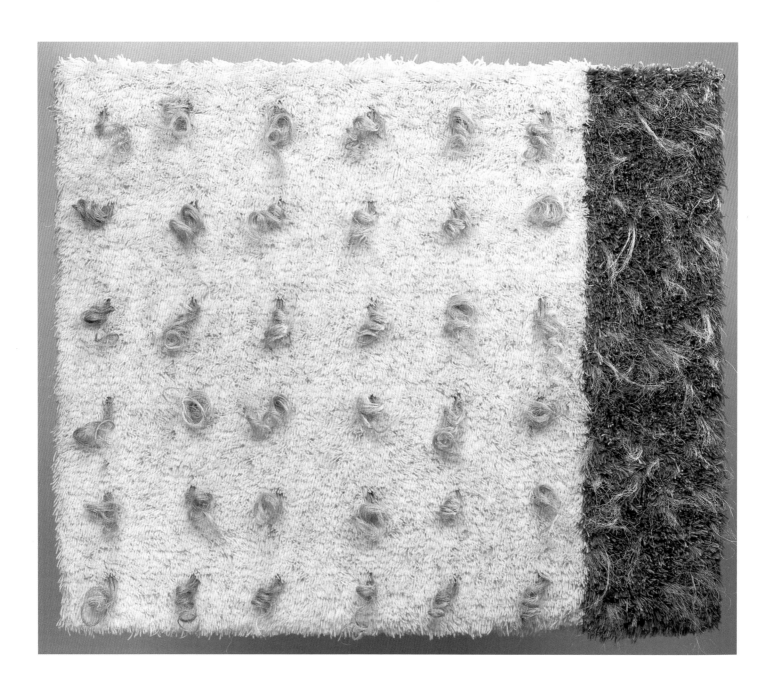

Spring
1998
rya-rug, wool, linen,
dyed sisal
95 x 115cm

Born 1931, Ii, Finland
Atelier Helsinki, Finland

Education and Awards

1953-56	Institute of Industrial Arts, Helsinki
1956-57	Free Arts School, Helsinki
1981	Finnish State Award for Design
1991	Mentions: Finland Forms
1992	The Engel Award
1992	Pro Finlandia Medal
1996	Textile Artist of the Year, Finland
1997	Alfred Kordelin Foundation Award
2000	Winner of 2000 Jubilee competition to design a commemorative ecclesiastical coin for production by the Mint of Finland, Helsinki

Exhibitions

2003	20 Jahre Internationale Textilkunst in Graz, Austria
2002	Meditation Space, UNESCO (solo), Paris
	Oulu Art Museum (solo), Oulu, Finland
1999	Artisti in Viaggio VI-Taiteilijat Matkalla, Kerava Art Museum, Kerava, Finland
1998	International Triennale of Tapestry, Lodz, Poland
	'Nature as Object', Art Gallery of Western Australia, Perth, Australia
	Artisti in Viaggio, Galleria Via Larga, Florence, Italy
1997	3rd Triennale de Tournai, Belgium
	Rundetaarn (solo), Copenhagen, Denmark
	'The Aesthetics of Everyday', The Design Center, Nagoya and Azabu Museum, Tokyo, Japan
1996	Rovaniemi Art Museum (solo), Rovaniemi, Finland
	'Intention', Liljevalchs Konsthall, Stockholm, Sweden
	Arts Decoratifs Finlandais, Musée de l'Hospice Comtesse, Lille, France
1995	Design Finlandais, Musée d'Art Moderne et d'Art Contemporain, Nice, France

Collections

Design Museum, Helsinki
Sara Hildén Foundation, Tampere, Finland
Pori Art Museum, Pori, Finland
State of Finland
Röhsska Konstlödjdmuseet, Gothenburg, Sweden

Publications

2001	*Textile Art in Finland* edited by Tuula Poutasuo, publ. by Akatiimi

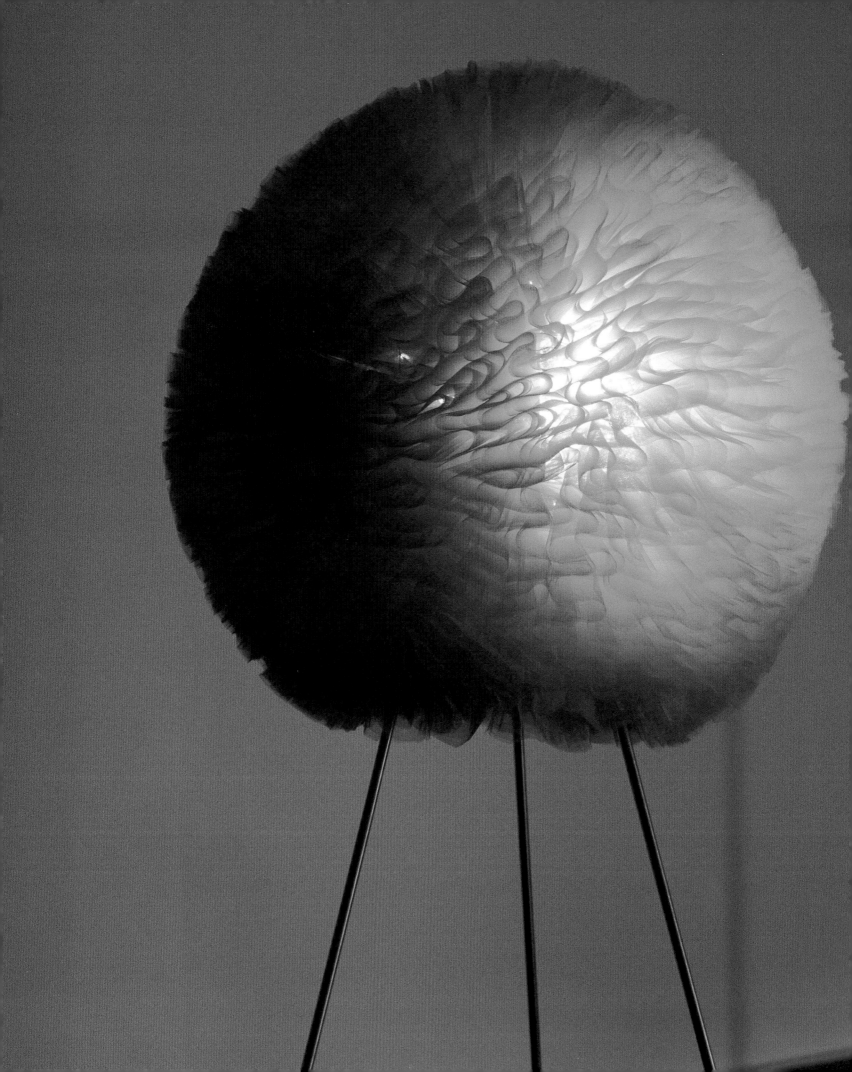

Monica Nilsson

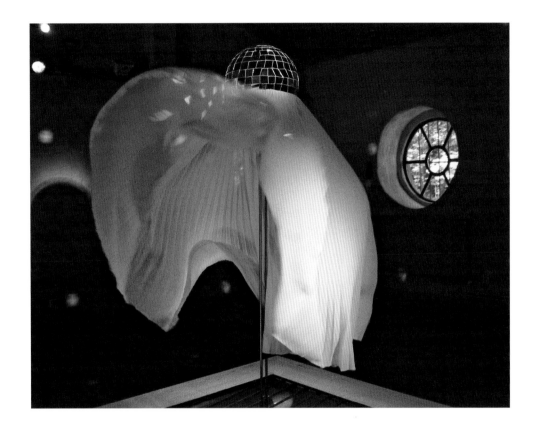

What can you do with cloth, colour and light, light-coloured cloth?

left:
The Green Ball
1998
object in tulle, TV with
video, 'Footballgame',
tripod
100 x 100 x 200cm

above:
The Skirt
2002
spinning object in pleated fabrics,
globe with mirrorglass, wood, iron
and blowers
190 x 300cm diameter

What can you do with cloth, colour and light, light-coloured cloth? A throbbing ball in a piercing green tulle, lit from the inside. Inside, a football is being kicked. The light shifts depending on what colour is currently on the screen. The cloth guides a nd materialises the light and the green colour gives the object a positive energy.

Textiles (cloth), colour and light are the three corner-stones of my work. I aim for simplicity, and a synthesis where the different parts strengthen and co-operate with each other in various ways. This is combined with motion, patterns, perforation, picture fragments, transparency, and pruning. Out of that, I set the stage for textiles with a content which is open for different interpretations and assocations. A sort of prototype of elements: heaven, yearning, water, sorrow, energy, home, and so forth. Memory and imagination (fantasy) are put in motion.

A transparent cloth, with the character of glass when a strong sunbeam finds its way through, is materialised before my eyes. The cloth is cut in a circular way, like my favourite teenage skirt only much larger: a semi-circle of 10 metres of cloth. The deep fold (pleat, tuck etc.) which is formed beneath gives the impression of a sculptural image.

A box of transparent cloth which has been painted red on one side. I cut out a circle in the red part, and paint a large dot on the other side. The sun creates a lighted spot on the back of the cloth. As the light moves, the spot shifts in relation to the painted dot - almost like a sundial. Or another box, bigger in size, with thin 'spider-legs', and brown, with a hole, like an eye. I think of a box-camera or an old cabinet which is filled with heavy impressions and events from the past: brown sorrow.

The mode of procedure is almost always the same: I try different effects by pruning textiles in various ways, and by painting and brightening specific cloths. I work with fans, and put areas where light is let through against painted surfaces. And while I examine different possibilities, my mind sometimes recalls various events and visual images in the past, which then affect the shaping of my works.

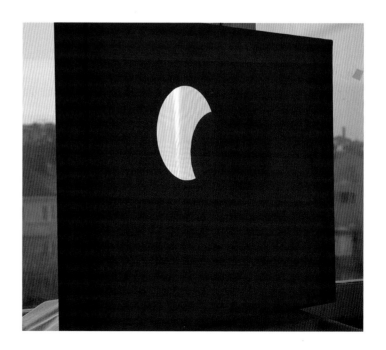

right:
Red Box
1997
frame covered with painted
and perforated monolen
6 x 58 x 42cm

far right:
The White Cloth
1998
transparent monolen
50 x 300 x 300cm

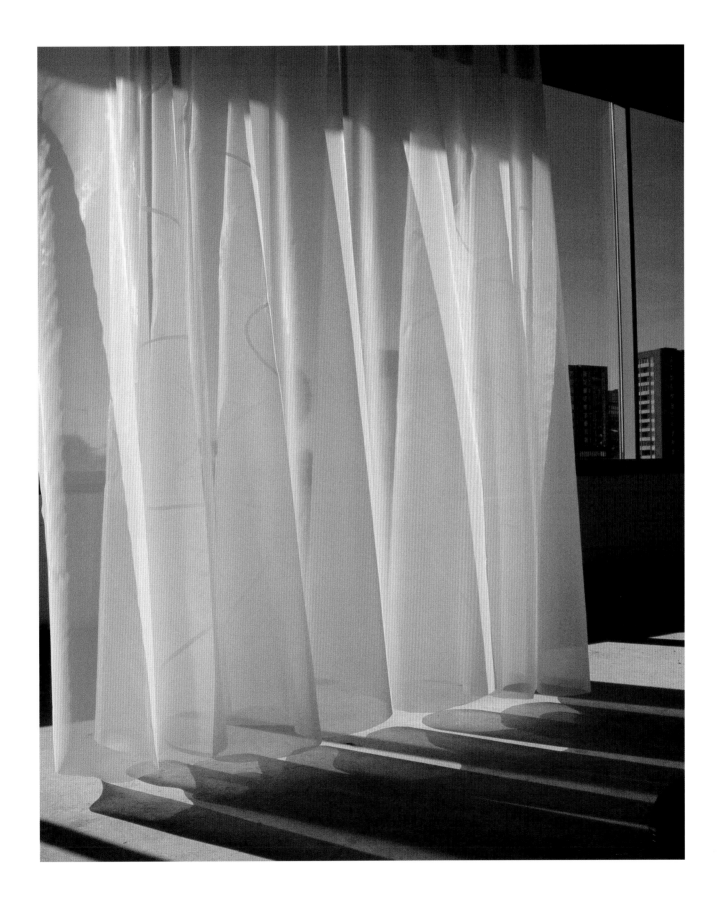

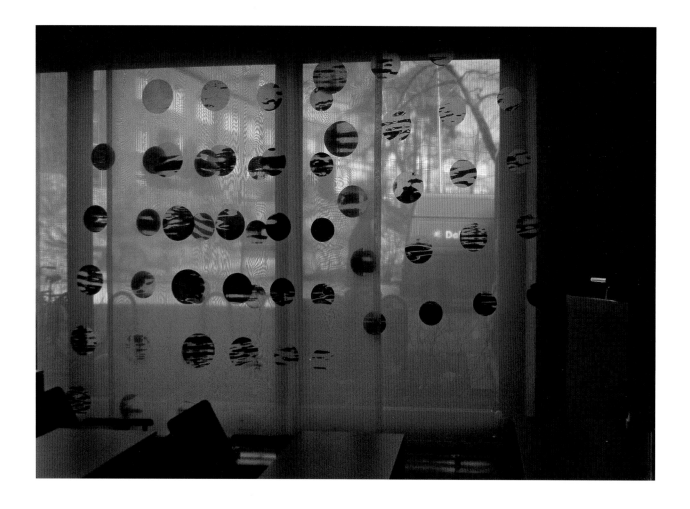

Personal experiences, role models, time and place, the specific materials in themselves: what consequences do these bring to bear? This question has led me to a more idea-based engraving, where I have attempted to become more aware of the factors that affect me; my own background; and the ambivalence of being trapped or seduced by a particular material. This subsequently led to the idea of *Labyrinth;* an inauguration of colour and material, a line of thought about creativity.

The latest instalment, *Room for Travellers*, is a result of the cooperation between me and Britta Carlström. In addition, we took in a musician and a dancer. This combination worked very well and we decided to develop the idea of dance, music and textile working together. It is actually a rather natural development considering the transparent materials used and the bulging, hanging and twirling textiles, the stage-set touch.

For me, the textile materials in all their uses are carriers of messages and meaning. Dreams, hopes, yearning, and experiences leave their marks in everyday objects. It is this charge that I strive to transmit into my objects. My textile objects can even trigger the ability to reminisce on past memories – as unreachable as the islands that float freely between the layers, in an unmade bed of light.

left:

**In Brugge every Mirror
is a sleeping water**
1998
layers of monolen, with trans-
mitted and processed photos
450 x 240cm

above:

Labyrinth (entrance)
2003
skeins of yarn, reels of cotton, fabrics,
pearls, old stuff from unfinished
projects, etc.
approx. 25m^2

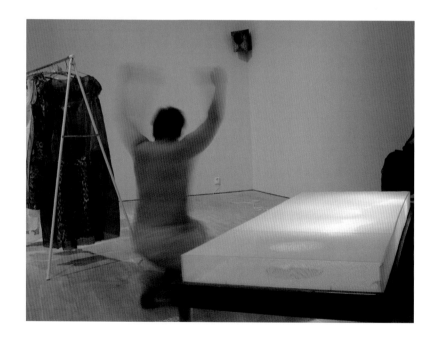

Room for Travellers

2005

installation in cooperation

with Britta Carlström

*My textile objects can trigger the ability to reminisce
on past memories – as unreachable as the islands
that float freely between the layers, in an unmade
bed of light.*

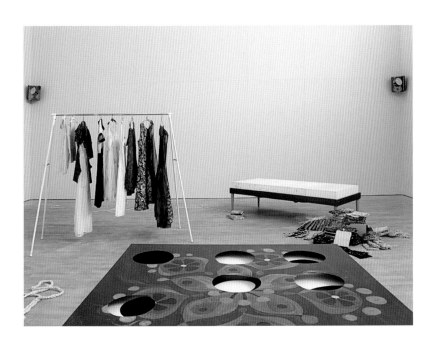

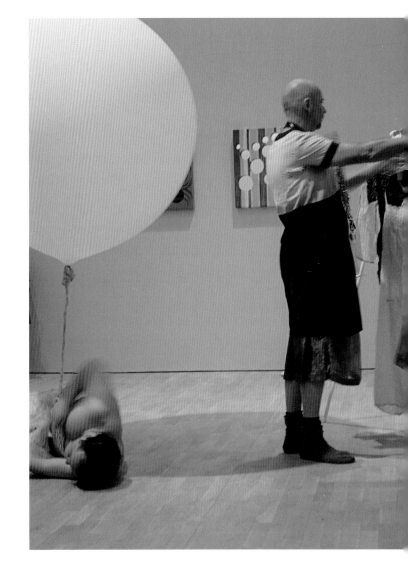

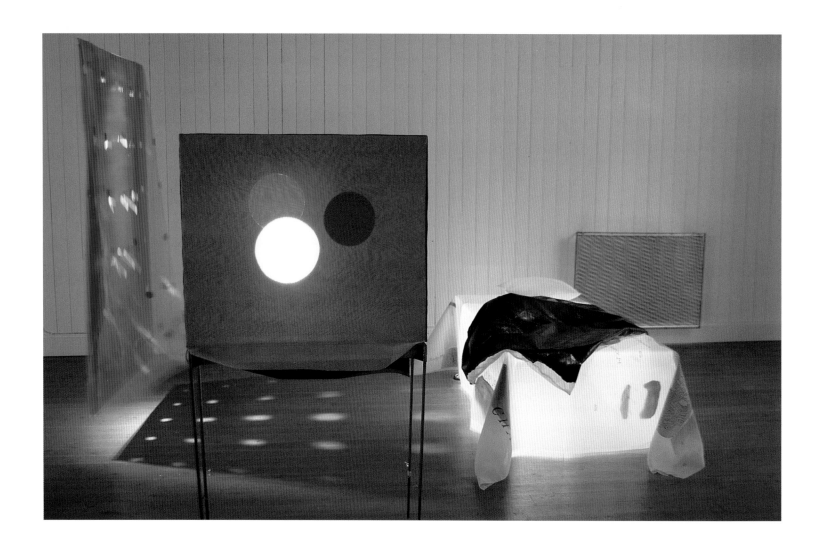

We all tend to hoard our scraps and off-cuts of fabric, whether in an attic or in our studio, to be used in the future. These rough drafts and fragments, materials, colours and patterns, arouse a lust where fantasy may obtain nutrition. I aim to capture these moments – where all roads are still open and where everything is possible.

Furniture
2001
installation

Born	1947, Östersund, Sweden
Atelier	Stockholm, Sweden
	www.fiberartsweden.nu

Education and Awards

1970-74	MFA University College of Arts, Crafts and Design, Stockholm
2000	The Nordic Award in Textiles 2000

Exhibitions

2005	'Room for Travellers', Haninge Artcentre, Stockholm
2004	'Home', The S Gallery, Östersund
2003	'Labyrinth', HV Gallery, Stockholm
2002	'My Marilyn', The Liljewalchs Art Centre, Stockholm
2001	Södertälje Konsthall
2000	Textile Museum, Boras
	Jämtlands Läns Museum
1999	'FAS4', with FiberArtSweden, Skulpturens Hus, Stockholm
1998	'Inside Her', Gallery Gra, Stockholm
1997	'Bright Spots', The Culture Factory, Sundsvall
	Botkyrka Art Centre, Stockholm
	Sandvikens Konsthall
1995	Swedish representative at the International Triennial of Tapestry, Lodz, Poland
1993	Konstförmedlarna, Stockholm
1992-93	'The Nordic Textile Triennial'
1990	The Theatergallery, Kalmar
1989	The Ahlbergshall, Östersund
1987	The Middlenordic Festival of Art, Trondheim, Norway

Collections

The National Museum of Art, Stockholm
The Museum of Jämtland
The Artmuseum of Gothenburg
The Swegmark Collection

Commissions

1987-2005	Various places like institutions, hospitals and colleges in Sweden

Publications

'Form', *Swedish Design Magazine* nr 5, 2003

Korea

Winter 2005 | ISBN 1 902015 07 X | Edited by Mi-Kyoung Lee and M. Koumis

Featured Artists:

Burn-Soo Song

Kea Nam Cha

Young Soon Kim

Ja Hong Ku

Soo-Chul Park

Shin Ja Lee

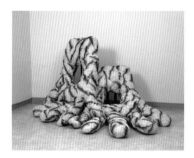

Kyung-Yeun Chung

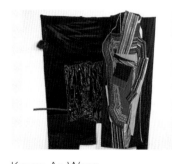

Kyung-Ae Wang

So-Lim Cha

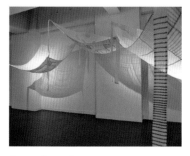

Sung Soon Lee